THE GLOUCESTER
& SHARPNESS
CANAL

THROUGH TIME

Hugh Conway-Jones

AMBERLEY PUBLISHING

Acknowledgements

I am very grateful to the following organisations and individuals who have made photographs available: Michael Beynon 7; Margaret Boakes 19, 21, 22, 28, 34, 49, 58; Doris Butt 33; Cadbury Schweppes 38, 72; Canal & River Trust 16, 30, 78; Cedric Catt 39, 53; Owen Cole 89; L. E. Copeland 75; Les Dalton 50; Roy Derham 9; Anthony Done 84; Charles Ellis 47; Jack Evans 20; Graham Farr Collection 85; Dennis Fredericks 44; Gloucester Folk Museum Bullock Collection 59; Gloucester Waterways Museum 6, 10, 17, 23, 46, 56, 62, 70, 88, 90, Gloucestershire Archives 13, 25, 27, 29, 32, 35, 69, 81, 82, 86, 91, 95, 96; Henry Greening 73; Ken Hill 67; Bob Ingram 63; Jim Marshall 37; J. & C. McCutcheon Collection 74; Wilfred Merrett 24, 36, 45; Bev Minett-Smith 55; Robin Morris 57, 93; Mike Nash 19b; National Monument Record 77, 94; Jim Nurse 12, 14, 42, 61; Brian Organ 15; Neil Parkhouse 51; Eric Perkins 54; Priday Metford & Co. 83, 92; Railway & Canal Historical Society 31, 43; Bernard Shaw 87; Jon Shaw 40; Rod Shaw 18; James Timms 39; Charlie Wallace 80; Walwins Collection 26, 68; Richard Watkins 11, 71; Phyl Wilkins 8. I would also like to thank Dr Ray Wilson for commenting on the draft text.

Cover Photograph

Sailing ships in the Main Basin viewed from the North Quay in 1883 – a painting by Harley Crossley based on an old photograph. The ships were moored to buoys in the centre of the basin so that salt could be loaded from longboats on either side at the same time. The same view in June 2010 shows a group of visiting Venetian rowers saluting before setting off up the River Severn.

First published 2013

Amberley Publishing
The Hill, Stroud
Gloucestershire, GL5 4EP

www.amberley-books.com

Copyright © Hugh Conway-Jones, 2013

The right of Hugh Conway-Jones to be identified as the Author of this work has been asserted in accordance with the Copyrights, Designs and Patents Act 1988.

ISBN 978 1 4456 1289 8 (print)
ISBN 978 1 4456 1309 3 (ebook)

British Library Cataloguing in Publication Data.
A catalogue record for this book is available from the British Library.

Typeset in 9.5pt on 11pt Celeste.
Typesetting by Amberley Publishing.
Printed in Great Britain.

A Brief History of the Gloucester & Sharpness Canal

The original plan for a ship canal between Gloucester and Berkeley was authorised by an Act of Parliament in 1793. The aim was to bypass the narrow, winding stretch of the River Severn below Gloucester, but the company ran out of money when only one third of the canal was completed. After several years of inactivity, work started again on a route to Sharpness, which was seen to be a better place for an entrance from the River Severn, and the canal was eventually completed in 1827.

The entrance at Sharpness comprised a tidal basin and a pair of locks: a large one for ships and a smaller one for barges. No transhipment facilities were provided – all vessels were expected to go up the canal to discharge at Gloucester. Initially there was one large basin at Gloucester for ships and a small side arm for barges, and there was a dry dock where hull repairs could be carried out. The Canal Company built a large warehouse at the north end of the basin just in time for the opening of the canal, and the various floors were rented to different merchants. As trade developed, more warehouses were built by merchants for their own use or by local investors who rented space to merchants.

The warehouses were mainly built for storing imported corn that was on its way to feed the growing industrial towns of the Midlands. Wheat, oats, barley, etc. came from Ireland, Europe and the Black Sea ports around the mouth of the Danube. Another major trade that developed was the import of timber, and this was particularly stimulated by the construction of the railways. Round logs and sawn deals came from the Baltic countries, the north of Russia and across the Atlantic from North America. To store the wood, extensive yards were established beside the docks and down the east side of the canal. Other imports included wines and spirits, fertiliser and some foodstuffs. Gloucester was well placed for this import trade as the canal allowed seagoing ships to come remarkably far inland, and narrow canal boats (known locally as longboats) could take the imports on up the River Severn and through the Midland canals to places like Birmingham, Wolverhampton and Walsall. Unfortunately, the only convenient export cargo was salt brought down the river from the Droitwich area, and many vessels departed empty to pick up coal from one of the South Wales ports. As well as being a highway for seagoing ships, the canal was also used by smaller vessels engaged in more local traffic.

In the early days, vessels were towed along the canal by horses, the number used being dependent on the size of vessel. There were originally fifteen double-leaf road bridges across the canal, and each side had to be opened to allow vessels to pass through. Initially, bridge keepers were recruited from people already living nearby, but in the 1840s the Canal Company started building special houses close to some of the bridges. These were built to a classical design, having a plan in the shape of a Greek cross with the arm facing the canal forming a porch having a pediment supported by two Doric columns.

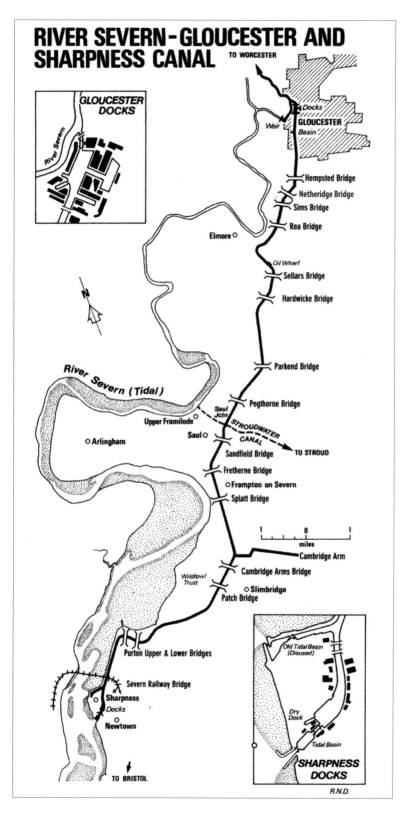

RIVER SEVERN – GLOUCESTER AND SHARPNESS CANAL

TO WORCESTER

GLOUCESTER DOCKS

River Severn

Docks
GLOUCESTER
Weir
Basin

Hempsted Bridge
Netheridge Bridge
Sims Bridge
Rea Bridge

Elmore O

Oil Wharf
Sellars Bridge

Hardwicke Bridge

N

River Severn (Tidal)

Parkend Bridge

Pegthorne Bridge

Saul Jctn
Upper Framilode
STROUDWATER CANAL
O Arlingham
Saul O
TO STROUD
Sandfield Bridge
Fretherne Bridge
O Frampton on Severn
Splatt Bridge

1 0 1
miles

Cambridge Arm

Wildfowl Trust
Cambridge Arms Bridge

O Slimbridge
Patch Bridge

Purton Upper & Lower Bridges

Severn Railway Bridge
Sharpness
Docks
O
Newtown

TO BRISTOL

Old Tidal Basin (Disused)

Dry Dock

Tidal Basin

SHARPNESS DOCKS

R.N.D.

Map of the
Gloucester &
Sharpness Canal

As trade continued to grow, additional quays were constructed beside the canal at Gloucester, and a second basin was opened in 1849, now known as the Victoria Dock. More warehouses were built, more timber yards spread further down the canal and a second dry dock was provided to suit the larger ships that were using the canal. Railway links were brought into the docks area, with the Midland Railway serving the east side and the Great Western Railway serving the west side. These railways were helpful in providing additional ways of distributing foreign imports, but they led to a considerable reduction in coastal traffic. During the second half of the nineteenth century, the docks area became a focus for the development of industries related to the corn and timber being imported.

During the 1850s, the Canal Company allowed passenger steamers to start operating regular services on the canal. These soon became very popular, taking Gloucester people to enjoy a visit to the pleasure grounds at Sharpness or enabling those living in the canal-side settlements to go shopping in Gloucester.

The 1860s was a particularly busy time for seagoing ships on the canal, and the Canal Company arranged for the introduction of steam tugs to take over towing. However, as the size of ships used in world trade was increasing, some were too big to pass up the canal to Gloucester, and so a new dock was built at Sharpness in the 1870s to accommodate them. Warehouses were built at Sharpness, and a network of railways ran round both sides of the dock, with links to the main-line Midland Railway and to the coal-mining area of the Forest of Dean via a multi-span bridge crossing the Severn estuary. At the same time, the Canal Company changed its name to the Sharpness New Docks & Gloucester & Birmingham Navigation Company, known locally as the Dock Company.

As the size of ships continued to increase, a growing proportion had to discharge at Sharpness, and traffic on the canal gradually changed to a predominance of barges and lighters towed by tugs. Many of these passed through Gloucester on their way to the Midlands, and the need for handling and storing goods at Gloucester slowly declined. The trade of the port was very badly affected by the First World War, as much of the traffic had come from European ports that were occupied or blockaded. However, the 1920s saw the development of a new role for the canal – carrying petroleum products on their way to the Midlands. Some of the petroleum came in coastal tankers, but most was delivered by a fleet of small tanker barges, and these became major users of the canal for many years.

During the Second World War, the canal played a vital role in moving cargoes inland that had come into the Bristol Channel ports via the Atlantic convoys. After the war, the Dock Company did not have the resources to finance the improvements needed to maintain competitive trade, and the company was nationalised in 1948 along with most other canal and dock companies. Subsequent improvements to the canal structures succeeded in attracting small ships to Gloucester again, and there were many tanker barges carrying petroleum products. However, most of the barge traffic died out in the 1960s and ships ceased using the canal in the 1980s due to the growing use of pipelines, containers and modern road transport. Sharpness continues as a successful port, handling bulk cargoes such as cement, grain, fertiliser and scrap metal.

The photographs in the following pages show how Sharpness has changed dramatically over the years to suit modern practices and how the canal scene has changed with modern steel bridges and pleasure craft replacing commercial traffic. The photographs also show that most of the old buildings at Gloucester have survived and been found new uses, making the dock estate a popular visitor destination with many modern facilities.

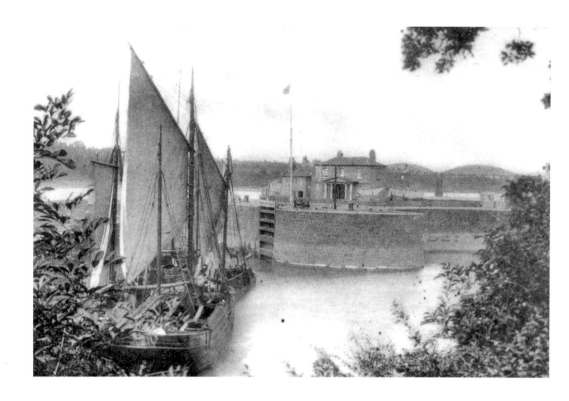

The tidal basin of the original entrance at Sharpness with sailing vessels preparing to depart c. 1905. When the rising tide in the estuary reached the level of water in the basin, the entrance gates were opened, any outgoing vessels departed and then incoming vessels could enter. Now the entrance is closed by a dam which maintains a high level of water in the basin.

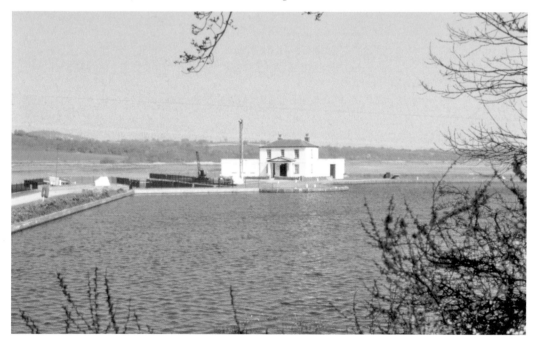

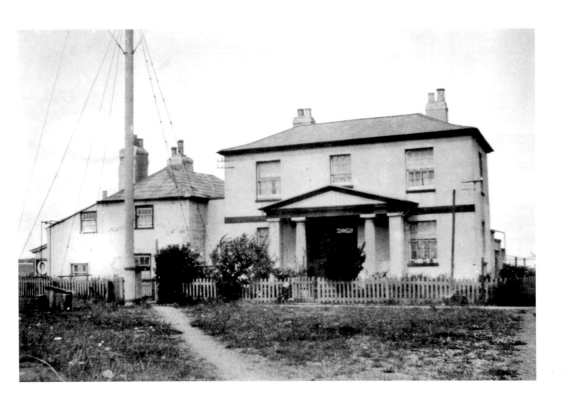

The harbour master's house beside the original entrance *c.* 1920. The harbour master was in charge of the men who helped vessels in and out of the entrance. The original building is on the left, and the more imposing block on the right is an extension built in 1853. The newer building is now the headquarters of a branch of the Severn Area Rescue Association, and the modern extension to the left was built for their rigid inflatable rescue boats.

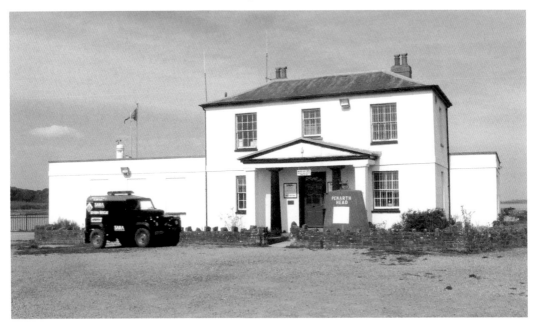

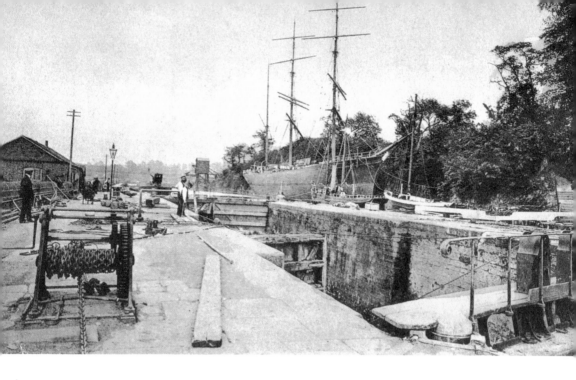

The original ship lock at Sharpness which gave access from the tidal basin into the main canal. The building on the left was the stable for the horses that towed vessels up the canal to Gloucester. This section of canal is now occupied by Sharpness Marina, which is protected from the prevailing south-west winds by the high ground on the right.

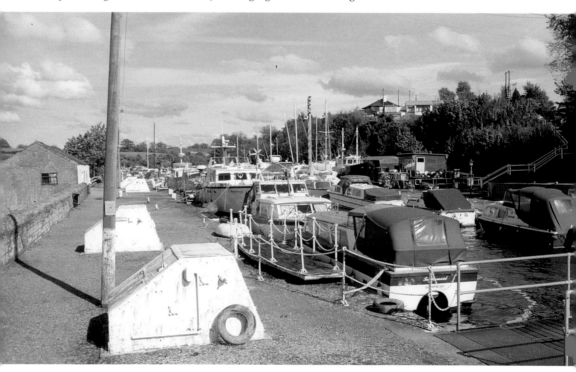

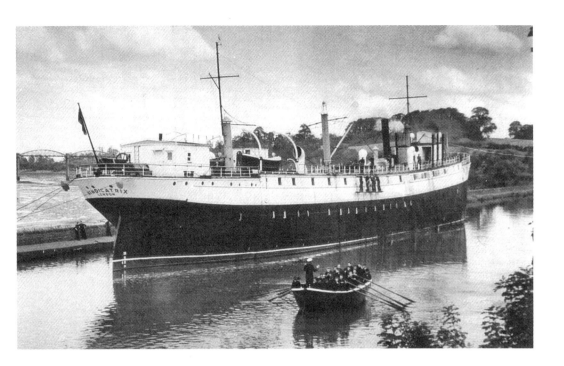

Training ship *Vindicatrix* in the old arm at Sharpness. Between 1939 and 1966, this former sailing ship was used for training about 70,000 boys for service in the merchant navy. The site of her mooring is now part of Sharpness Marina, but her role is remembered by a plaque on the former stable building.

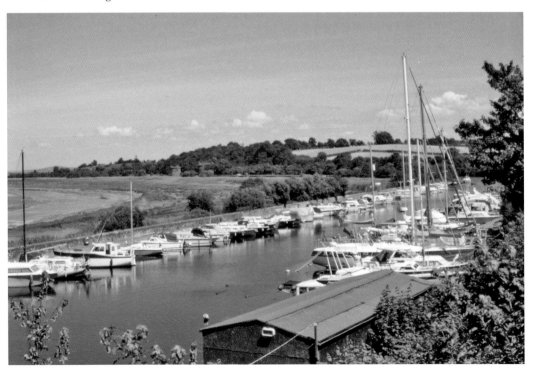

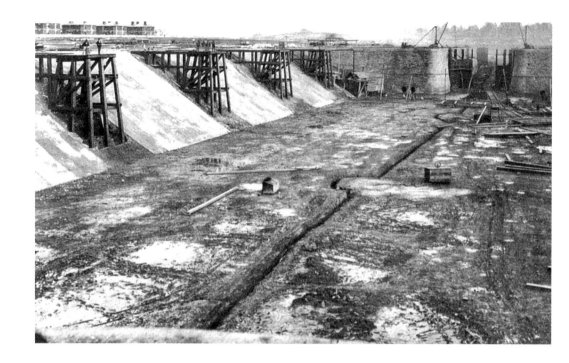

The new tidal basin at Sharpness under construction, November 1873, looking east towards the new main dock. These were opened in 1874 to provide facilities for the larger ships then in service to discharge cargoes. The lower photo shows that this entrance is still used by commercial shipping with the original timber jetties having been replaced by concrete.

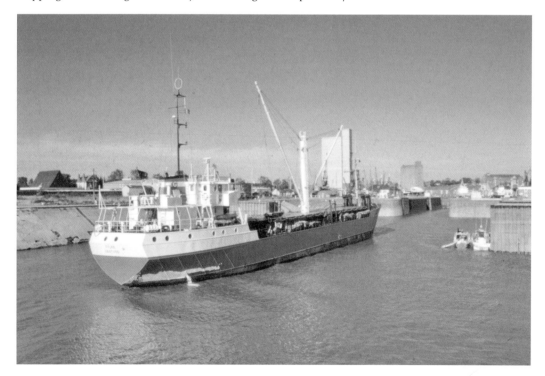

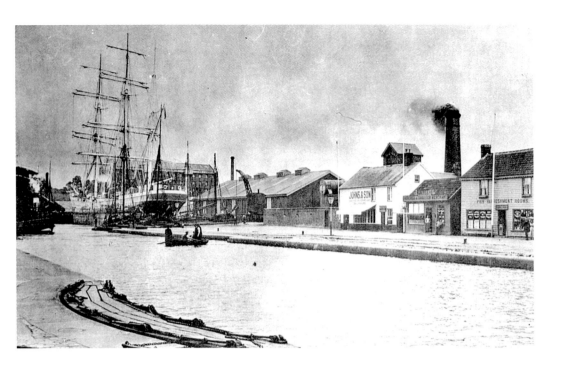

The new entrance lock at Sharpness looking east towards the main dock. In the foreground, the lower lock gate was open as the tidal basin was being used as an extension to the lock to accommodate a particularly large ship. On the opposite side of the lock were shops, offices and a coffee house, and the chimney belonged to the hydraulic station, which provided power for operating the lock gates. Now, Navigation House includes offices for the Port Authority who administer the dock and for the Gloucester Harbour Trustees who manage the navigation marks in the estuary.

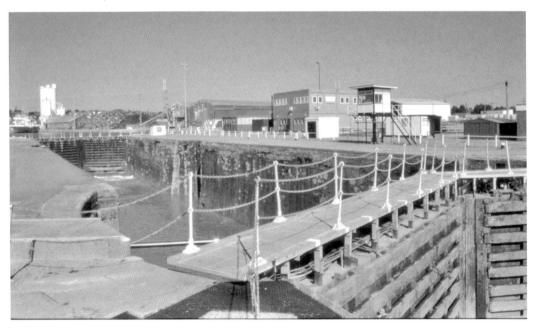

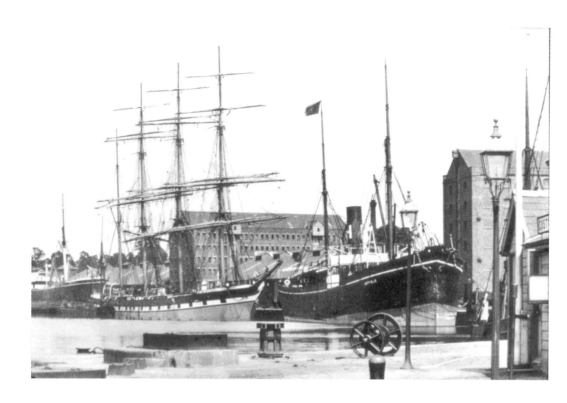

The south side of Sharpness Dock with Albert and Pioneer warehouses viewed from beside the lock in 1892. The four-masted barque brought 2,618 tons of wheat and barley from San Francisco, and the steamer arrived with 2,284 tons of beans from Alexandria. The two warehouses have since been demolished, and this part of the dock is now used for shipping out scrap metal.

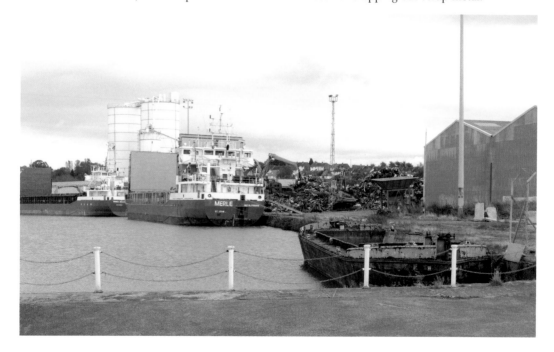

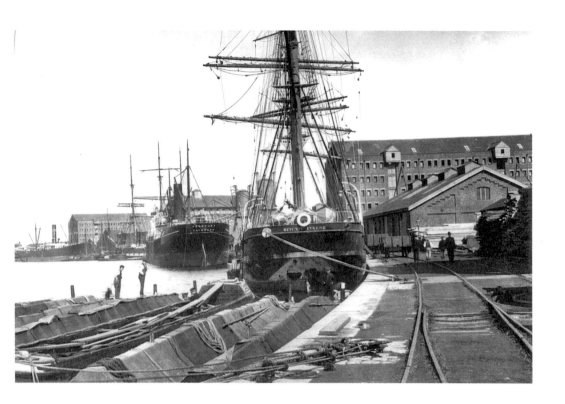

The east side of Sharpness Dock with North, Severn Ports and Albert warehouses in 1905 (GA GPS 287/52). The steamer brought 3,487 tons of wheat from Nicolaief and the barque arrived with 1,405 tons of wheat from Rosario. The site of the Albert Warehouse is now occupied by silos for storing imported cement, and MV *Maria Muller* is a regular visitor.

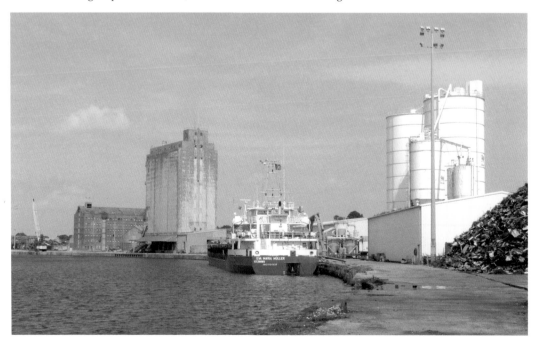

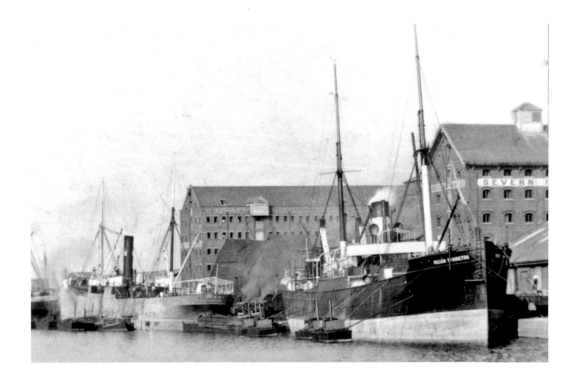

The east side of Sharpness Dock with North and Severn Ports warehouses in 1898. The nearer steamer brought 2,394 tons of barley from Odessa, and a number of floating steam winches are alongside to help with the discharging. Severn Ports Warehouse was destroyed by a disastrous fire in 1934, and it was replaced by a concrete silo.

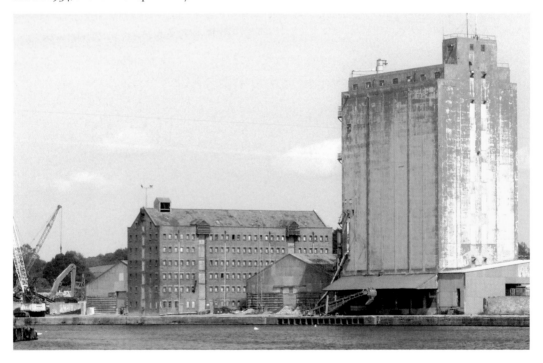

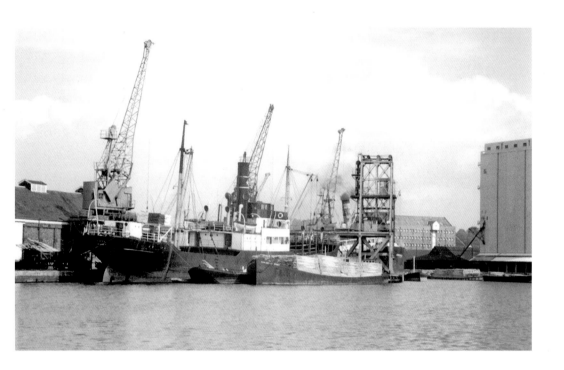

The west side of Sharpness Dock where ships discharged timber to lighters for onward transit to Gloucester, *c.* 1955. The vertical structure mid-right was a hoist for tipping trucks that had brought coal from the Forest of Dean for export or for bunkering steamers. The east side is now dominated by a grain silo built in the 1970s.

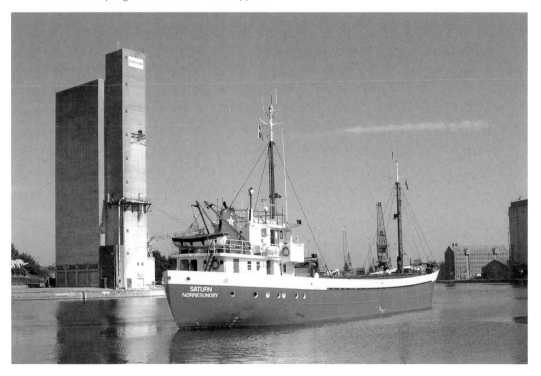

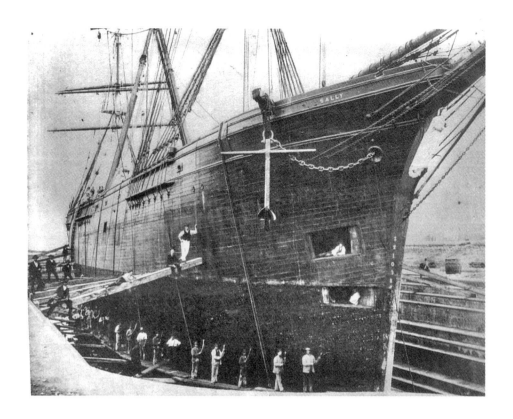

The ship *Sally* in Sharpness dry dock in 1875 with an opening near the bow for discharging long baulks of timber. The dry dock was built as an integral part of the new dock project to provide repair facilities for large ships. The dock is still in regular use for overhauling vessels such as the dredger *Cork Sand*, which has a hull that can split open to deposit its contents.

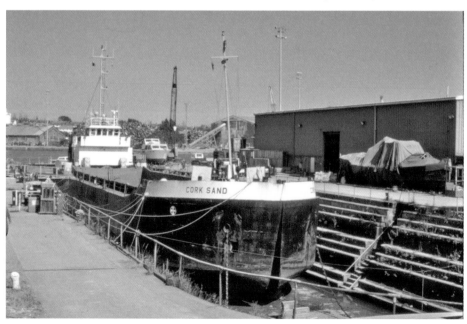

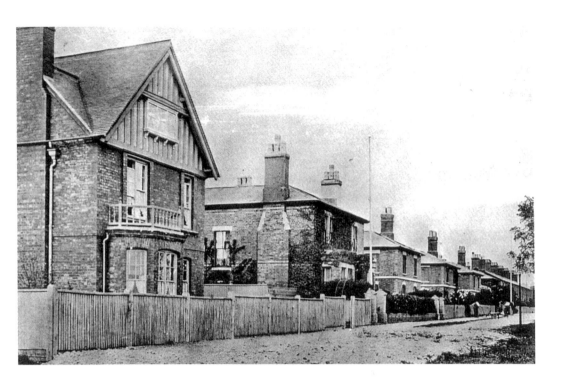

Dock Row on the high ground to the west of Sharpness Dock. The house with the flagpole was built for the harbour master, and those beyond were for key workers at the new dock. The big house on the left was a later addition for the dock manager. Many of the houses are still occupied by current or retired dock workers.

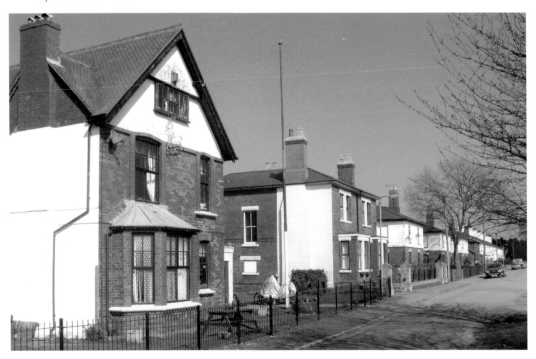

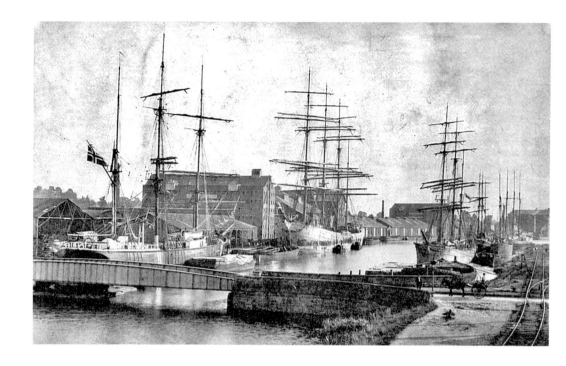

Sharpness Dock viewed from the high-level bridge with the North Warehouse on the left and the low-level bridge in the foreground. Sights such as this made Sharpness a popular place to visit, and pleasure grounds were established with fine views over the estuary. Now, the North Warehouse is the only early warehouse to survive, and it is preserved as a Listed Building but no longer used for storage.

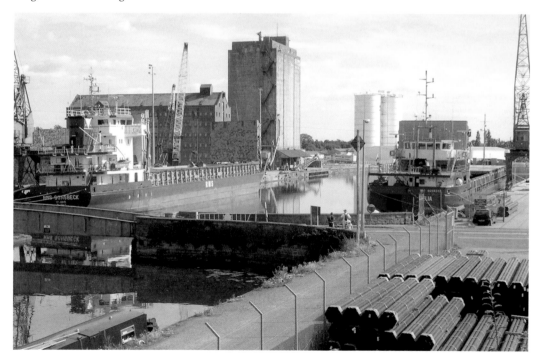

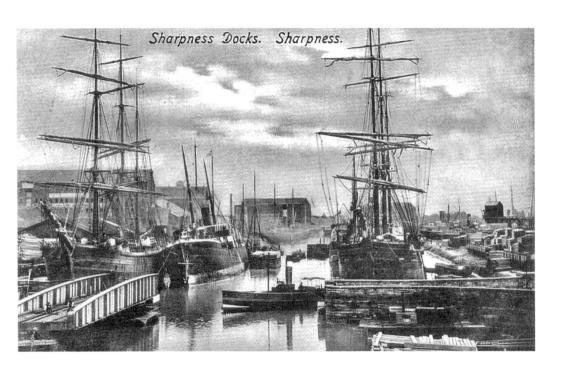

Sharpness Docks. Sharpness.

Another view of Sharpness Dock from the high-level bridge with the coal hoist in its original form far right. The tug *Myrtle* in the foreground was one of those that towed ships and lighters along the canal between Sharpness and Gloucester. The same view on 2 March 2009 shows six vessels in the dock, and there was a seventh out of sight.

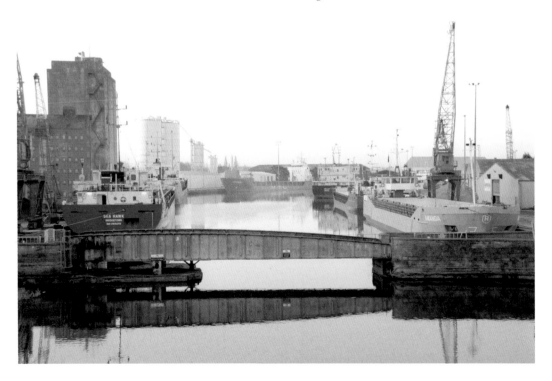

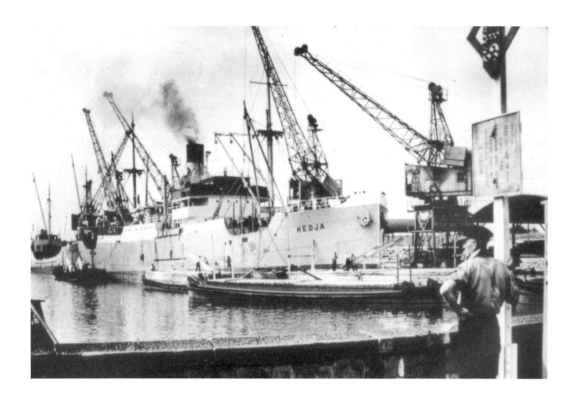

Timber being discharged from SS *Hedja* in 1959 viewed from the low-level bridge. The steamer is moored by the new quay built along the west side of Sharpness Dock during the Second World War, and the new electric cranes are being used as well as the ship's derricks. The former timber sheds behind this quay have been adapted for storing cargoes such as fertiliser and animal food.

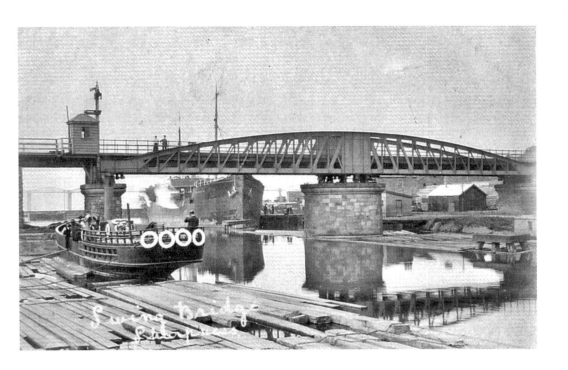

The passenger steamer *Wave* by the high-level bridge *c.* 1910. The bridge carried the railway line that brought coal from the Forest of Dean to the coal tip beside the dock. The *Wave* and the *Lapwing* maintained a regular service carrying passengers between Sharpness and Gloucester. The same view on 29 June 2004 shows MV *Kormoran* carrying oil-rig equipment manufactured in Gloucester on its way to the Norwegian sector of the North Sea – probably the last coaster to use the canal.

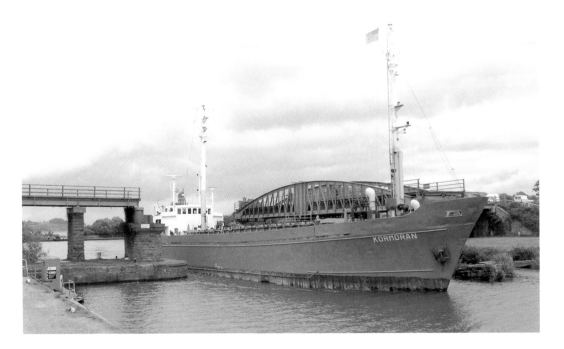

Sharpness Gas Works, a timber yard and the Steam Packet Wharf to the north of the high-level bridge *c.* 1905. The gas works supplied gas for lighting the docks and for use in local houses. Beside the Steam Packet Wharf is one of the canal passenger steamers and the Dock Company's steam launch *Sabrina*. The same view in 2010 shows the area largely taken over by nature, and since then the timber storage shed has been demolished.

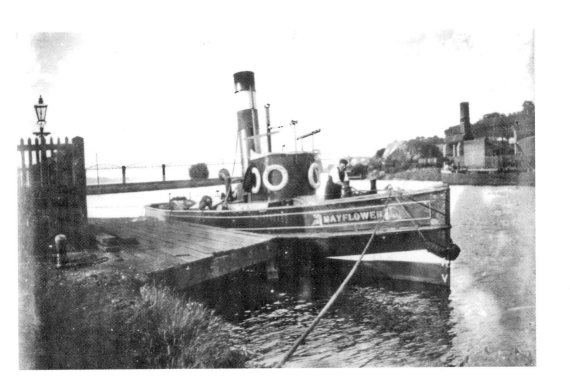

The tug *Mayflower* at the coaling stage north of the high-level bridge with the canal leading to Gloucester behind. *Mayflower* was one of a small fleet of steam tugs introduced in the 1860s to tow ships and lighters along the canal, replacing the horses that had been used earlier. This site is now part of the Sharpness Marina in the old arm away to the left.

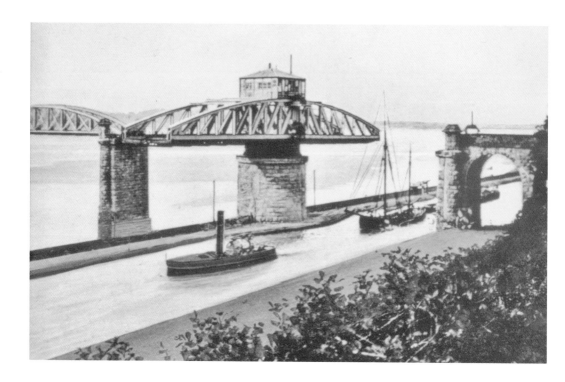

The moveable span of the Severn Railway Bridge swung open to allow a tug and its tow to pass through, *c.* 1910. The bridge carried the railway line that brought coal from the Forest of Dean to the coal tip beside Sharpness dock. The bridge was badly damaged one foggy night in October 1960 when two tanker barges collided with a column and overturned, and five crewmen died. Later most of the bridge structure was removed leaving just the stone columns either side of the canal.

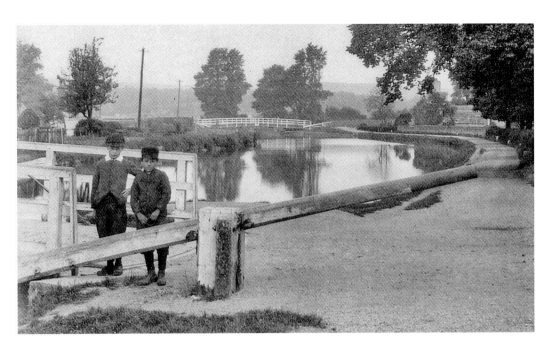

Two boys standing by Purton Upper Bridge *c.* 1890 (GA GPS 393/1). The original canal bridges had two wooden half-spans, and one half was swung open by a man pushing on the long beam in the foreground while a second man did the same on the other side of the canal. All of these old bridges have been replaced by single steel spans, and Purton Upper Bridge has automatic barriers and road traffic lights as it is controlled remotely from the Lower Bridge in the distance.

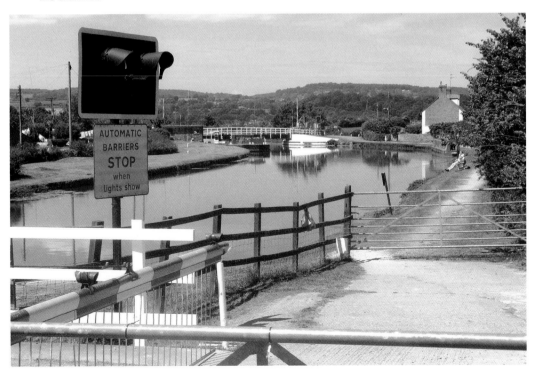

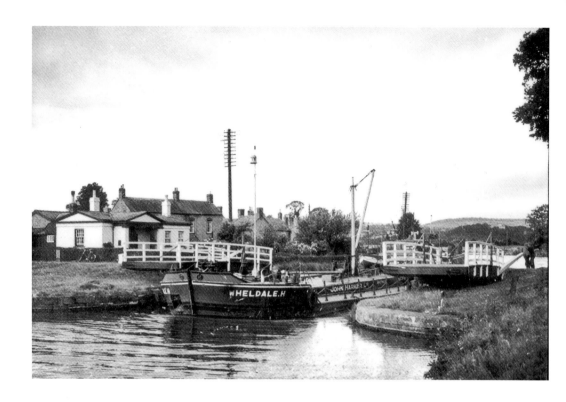

Tanker barge *Wheldale H* passing through Purton Upper Bridge in the 1950s. During the middle decades of the twentieth century, barges carrying petroleum products were the main traffic on the canal, loading at Avonmouth or Swansea and supplying depots at Gloucester, Worcester and Stourport. The same view today shows the Willow Trust's boat *Spirit of Freedom II*, which provides days out on the water for disabled and elderly people.

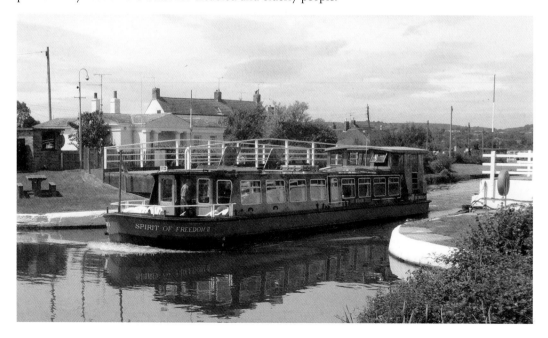

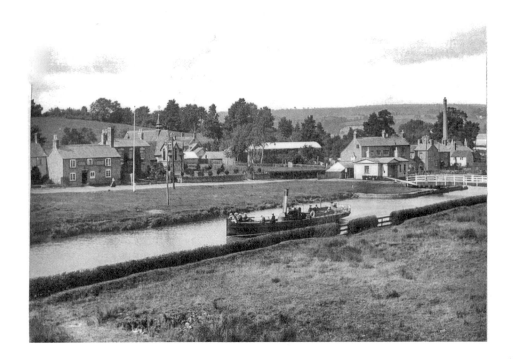

Passenger steamer *Lapwing* passing the green at Purton *c.* 1910 (GA GPS 393/7). *Lapwing* and sister vessel *Wave* maintained regular services between Sharpness and Gloucester, stopping at each bridge if required. Purton was a popular place of residence for Severn pilots who guided ships in the estuary and for canal pilots who steered visiting vessels along the canal.

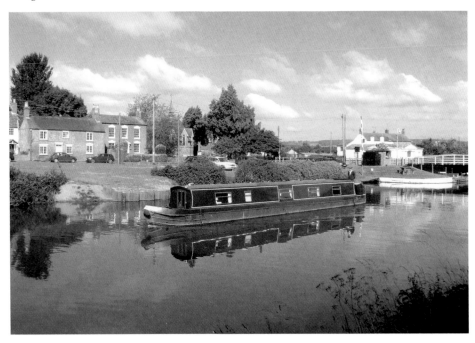

Patch Bridge at Slimbridge with two wooden half-spans. The black shed was built beside a small wharf to store corn on the way to Draycott Mill at Cam. The same view on 6 January 2009 shows the installation of a temporary fixed bridge that would carry the traffic while a strong replacement steel bridge was constructed to suit the heavy vehicles then visiting the Slimbridge Wildfowl and Wetlands Trust. The black shed (just visible) is now a café and cycle-hire centre.

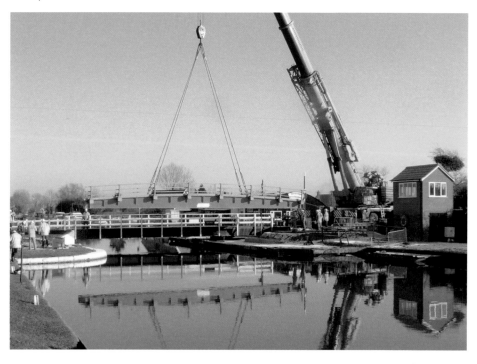

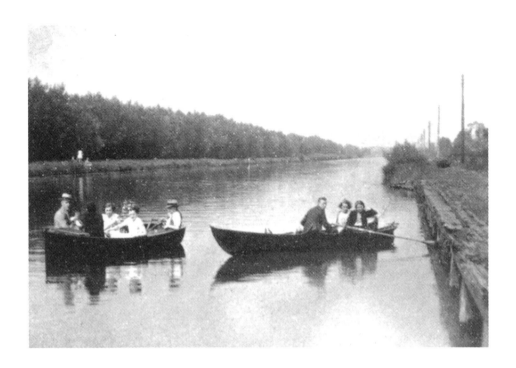

Two rowing boats beside Patch Wharf to the north of Patch Bridge *c.* 1950 (GA D1405 4/277). The rowing boats were for the use of guests at the nearby Patch Guest House. The wharf is now the base for Glevum hire boats, and the canal bank to the north provides long-term moorings for local pleasure craft. Also in the picture is the Willow Trust's *Spirit of Freedom II* returning from a lunch stop at Purton.

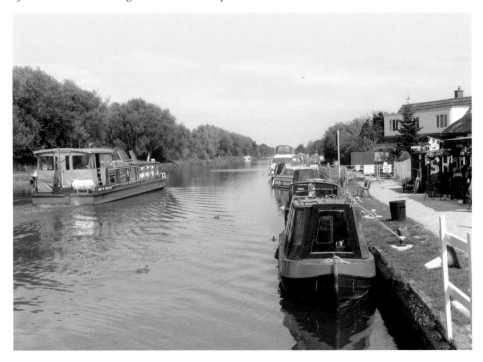

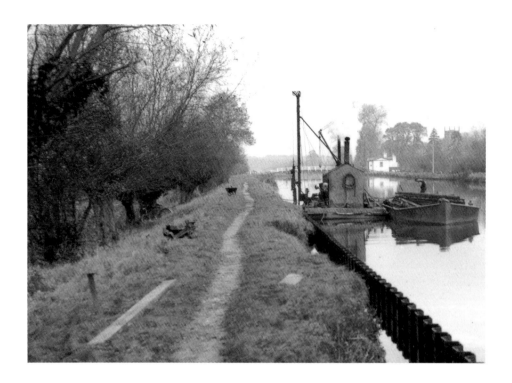

A piling rig at work below Splatt Bridge in the 1950s. Over the years, the canal banks had become badly eroded by the wash of passing vessels, and a major programme of piling was carried out using both steel and concrete piles. A similar view in 2000, soon after the towpath had been upgraded by the charity Sustrans to become part of Cycle Route 41, showing cyclists admiring a new signpost.

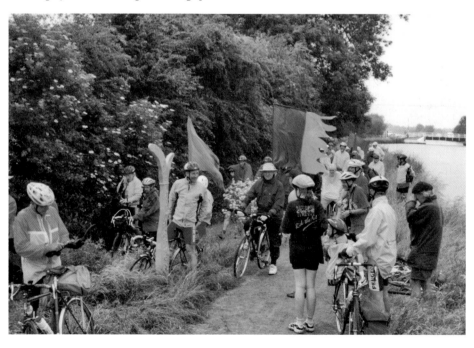

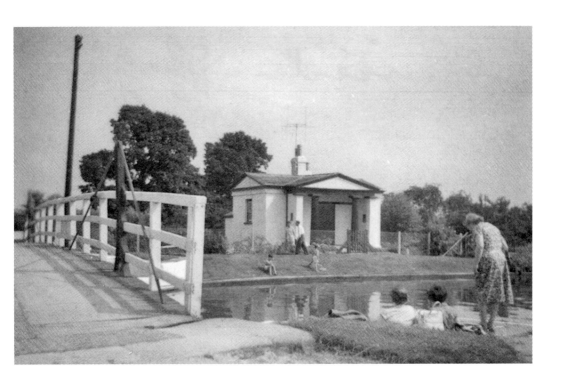

Splatt Bridge and the nearby bridge keeper's house in the 1950s. This is one of the eight bridge houses originally built to the same design with a delightful classical-style porch. The modern signpost shows that this section of the canal towpath is now part of the Severn Way, a long-distance footpath.

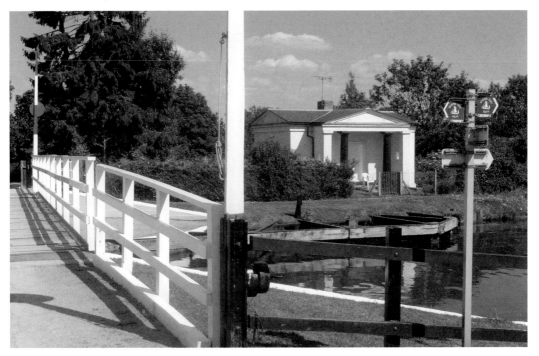

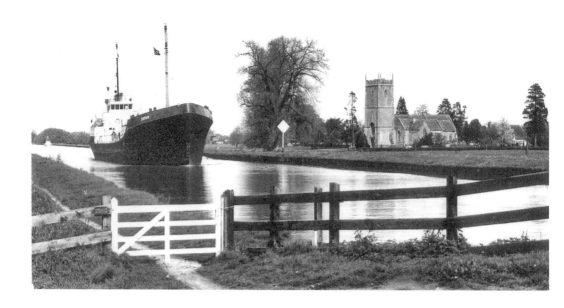

The coastal tanker *Borman* passing Frampton church on its way to Llandarcy near Swansea to load petroleum products for a depot at Quedgeley (GA GPS 149/44 Brian Smith). The same view today shows long-term pleasure-boat moorings on the right and visitor moorings on the left.

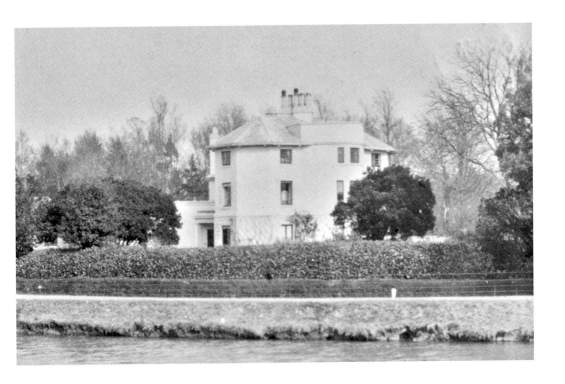

Saul Lodge south of Fretherne Bridge. Sited near the mid-point of the canal, the house was the official residence of the Canal Company's engineer until the 1890s. It was later bought and extended by Sir Lionel Darell, Bt. In recent years, the house has been divided into two residences.

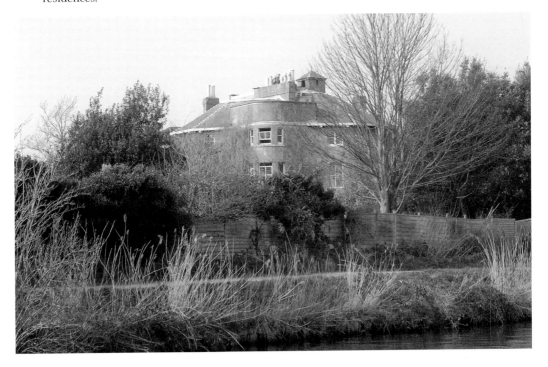

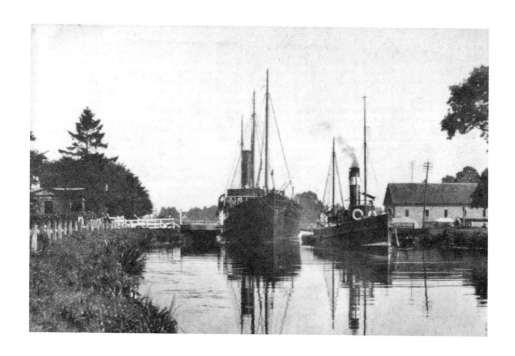

SS *Opal* being assisted through Fretherne Bridge in the 1920s. Steamers commonly required the assistance of a tug because of the difficulty of steering while moving slowly in the narrow channel. The same view in June 2009 shows the barque *Earl of Pembroke* on her way to the Gloucester Tall Ships Festival, watched by hundreds of spectators.

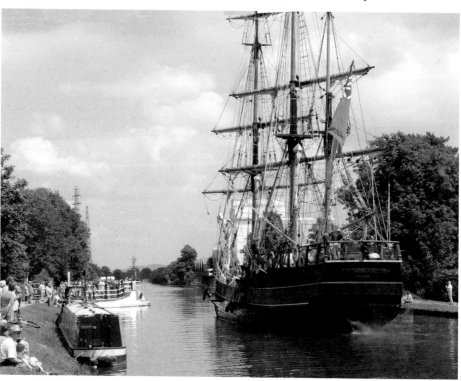

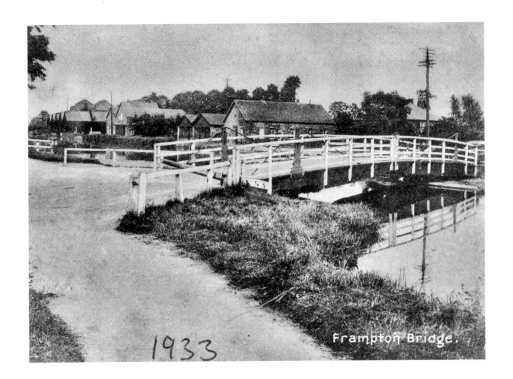

Fretherne Bridge *c.* 1930 with Cadbury's factory in the background (GA GPS 149/42). The warehouse partly obscured by the bridge was built to store wheat on its way to nearby Fromebridge Mill and later became the canteen for workers at Cadbury's factory. The modern Fretherne Bridge is operated from the adjoining cabin.

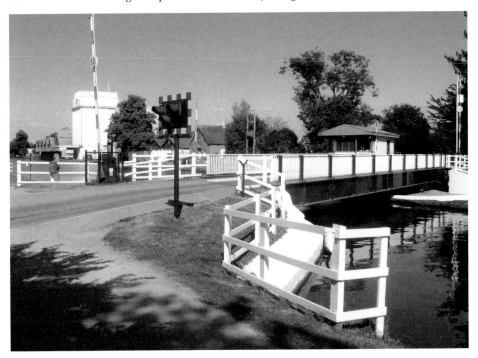

35

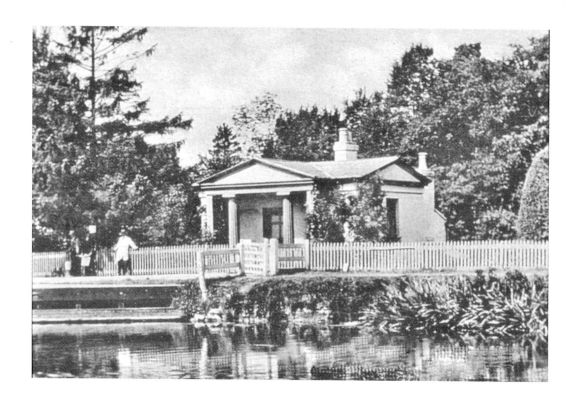

The bridge keeper's house at Fretherne Bridge *c*. 1905. The original house just had a living room, one bedroom and a scullery at the back. In recent years, additional accommodation has been provided by making the basement habitable and accessible from the lower ground beyond the canal bank, without altering the appearance of the building viewed from the canal.

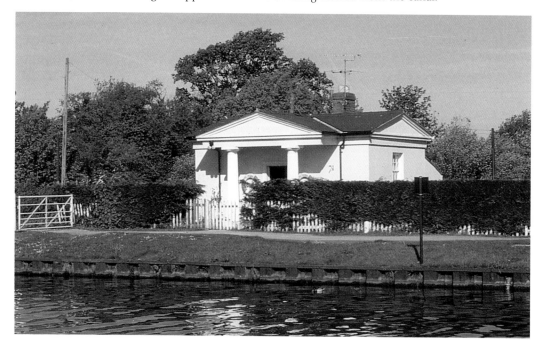

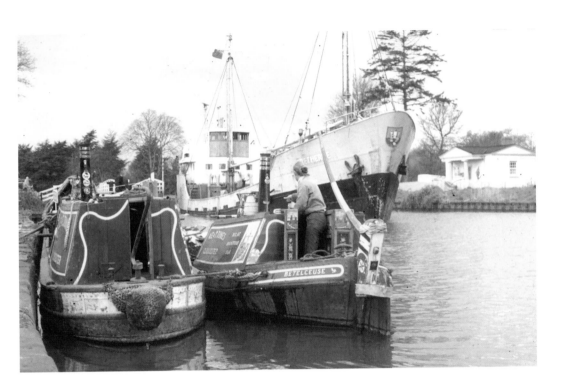

Narrow boats *Comet* and *Betelgeuse* discharging coal at Frampton Wharf in the early 1970s with the locally owned coaster *Fretherne* passing by and Fretherne Bridge House extreme right. At that time there were many customers who appreciated coal being conveyed by water, and even today the wharf is used occasionally for deliveries.

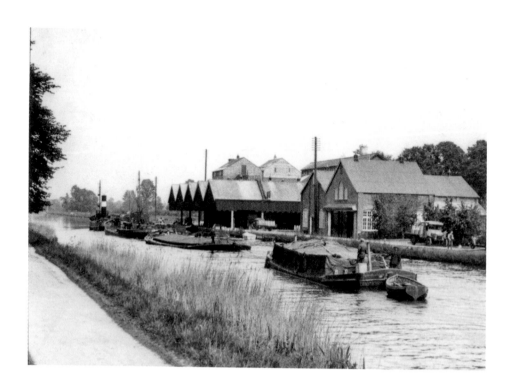

A tug towing barges past Cadbury's factory north of Fretherne Bridge. Milk from local farms was brought to the factory where ground cocoa beans and sugar were added, and the mixture was baked to make chocolate crumb, which was taken by boat to Bournville for refining. The same view today shows the original loading canopy and the later silo for storing the crumb, but the site is now a trading estate.

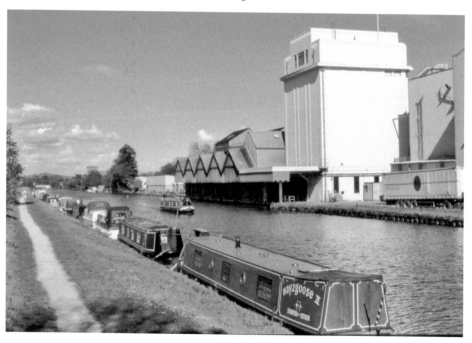

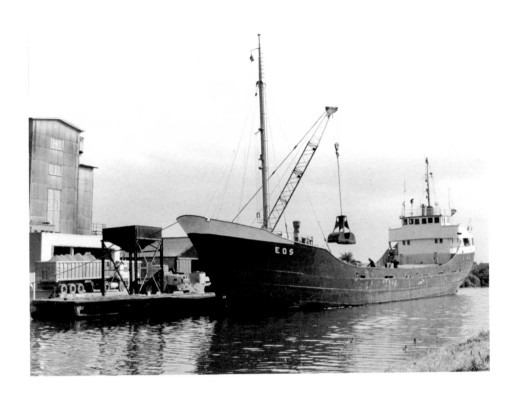

Bulk fishmeal being discharged from a coaster at Sandfield Wharf in 1987. The wharf south of Sandfield Bridge was built during the Second World War to serve a government food store that was developed after the war for handling a variety of imported cargoes. The same view today shows part of the original store on the right and the later grain drier on the left.

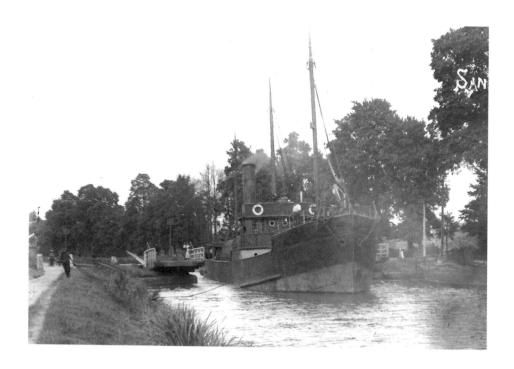

A steamer passing through Sandfield Bridge with a hobbler on the towpath carrying a rope from the ship. If the ship was going off course, the rope could be attached to one of the many checking posts along the towpath, and the ship's winch could be used to help correct the ship's direction. The same view today shows the single-span steel bridge that has replaced the former wooden half-spans.

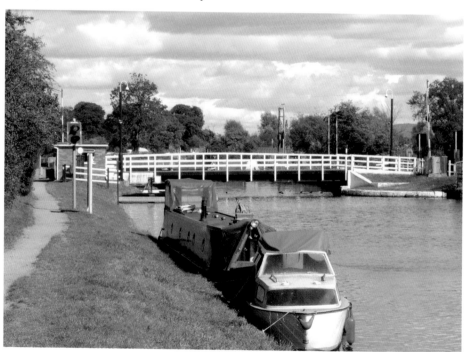

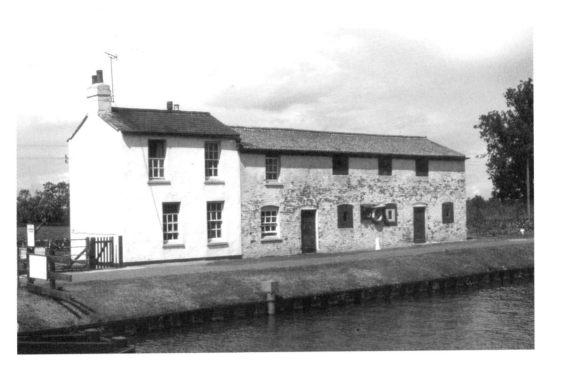

The bridge keeper's house at Sandfield Bridge and the former stables that were used by the towing horses when a tow could not be completed in a day. The horses were provided by groups of owners at Purton and at Gloucester, the number of horses needed for each size of vessel being specified in the Canal Company's bye-laws. The stable building has now been converted into the Stables Café.

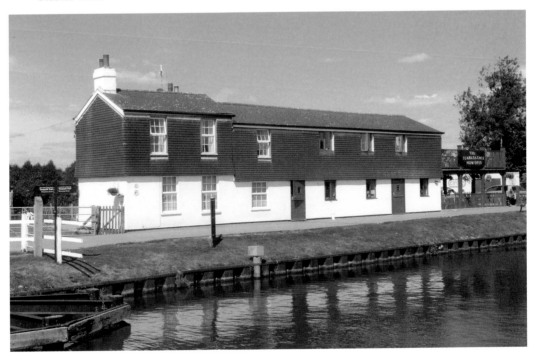

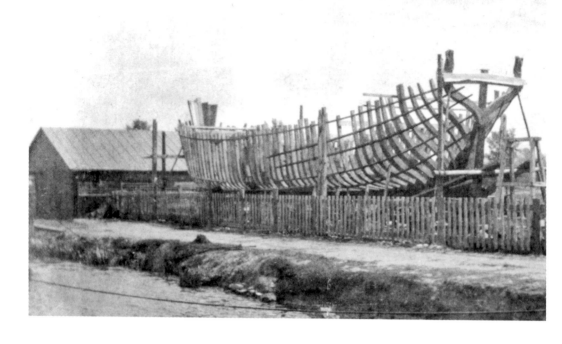

A sailing vessel under construction at Saul – probably the schooner *Julia* completed in 1891. The shed housed workbenches and equipment for the carpenters who maintained the bridges and lock gates. The area is now a boatyard for building and maintaining pleasure craft.

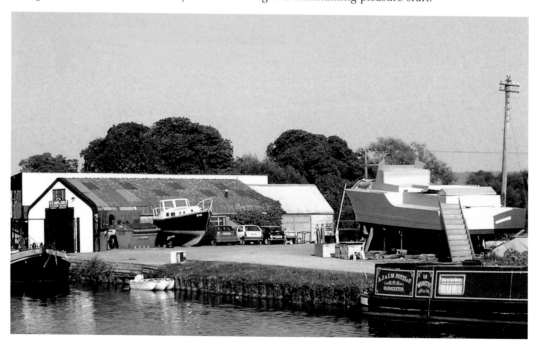

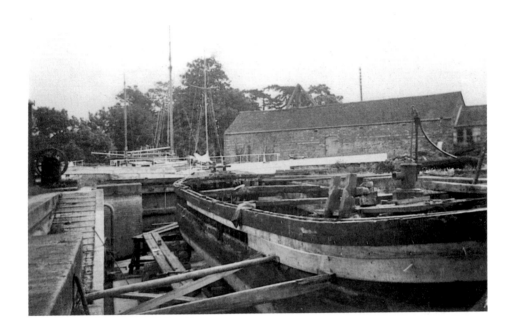

A 40-ton flat (maintenance boat) in the dry dock at Saul Junction (where the Sharpness Canal crosses the Stroudwater Canal). The dry dock cut across the corner of the two canals, and the building in the background is a boathouse which is accessed from the Stroudwater Canal. Now the dry dock is used for maintaining pleasure craft, and the lower picture shows the passenger boat *Queen Boadicea II* undergoing a major overhaul.

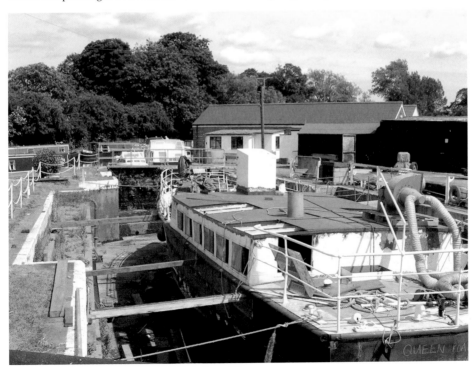

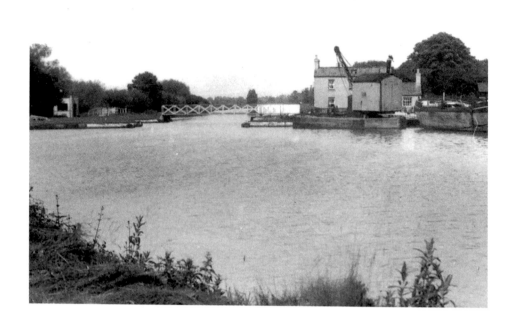

The basin at Saul Junction looking north towards Junction Bridge and House. The basin was used occasionally for transferring cargoes such as road stone from ships to narrow boats for delivery to places along the Stroud Valley. A similar view in 2008 shows the basin during the Saul Waterways Festival, a popular annual event for several years, organised by the Cotswold Canals Trust.

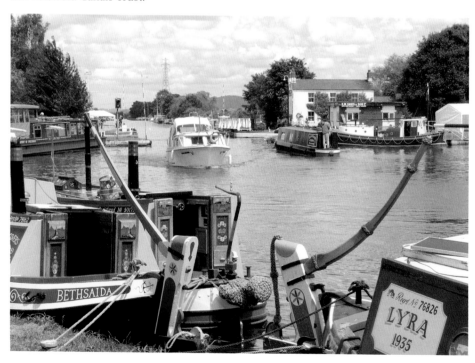

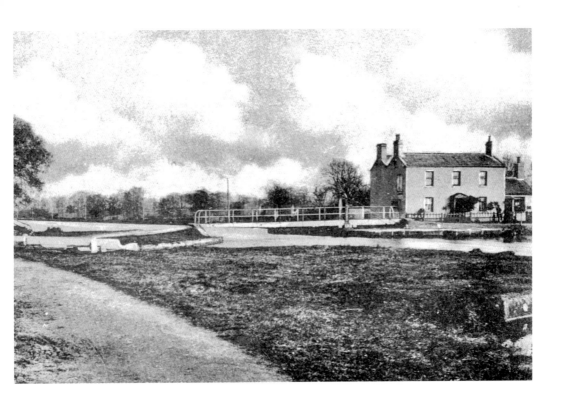

A postcard view of Saul Junction *c.* 1900. The bridge keeper who lived in the Junction House was also responsible for keeping a record of boats passing from one canal to the other and for collecting tolls. The junction today is a popular visitor destination with attractive landscaping, passing boats and a heritage centre open at weekends.

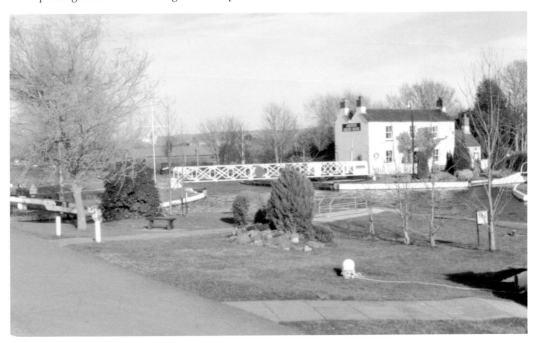

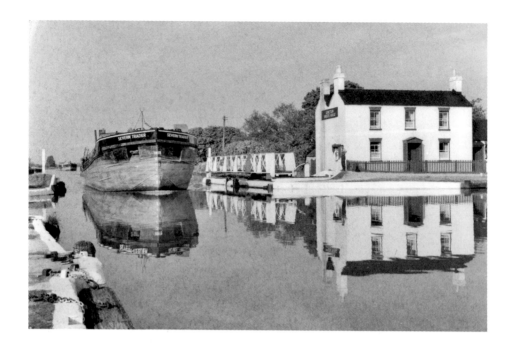

The motor barge *Severn Trader* passing empty through Saul Junction *c.* 1960. Motor and towed barges like this were very busy in the 1950s and 1960s, collecting imports at Avonmouth and carrying them inland to Worcester and Stourport. The same view in May 2005 showing a Russian-built schooner converted at Gloucester into a replica of HMS *Pickle*, the ship which brought the news of Nelson's victory at Trafalgar back to Britain.

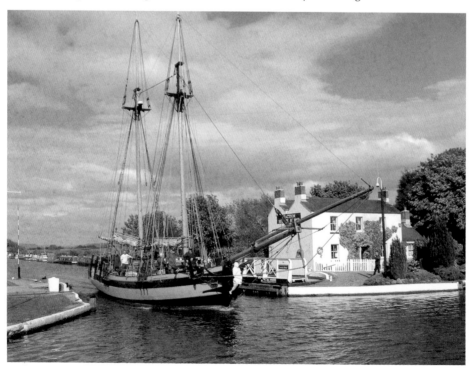

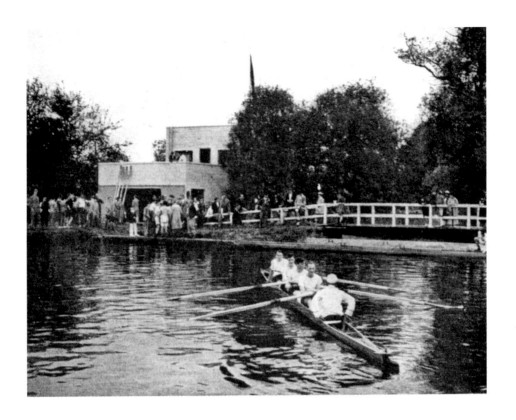

Wycliffe College first four at Saul Junction in 1938 with the college boathouse behind. During the Second World War, the boathouse was used as a base for maintaining RAF air-sea rescue launches. After the war, the boathouse was extended, and the college boys still make regular use of the canal for sculling practice and races.

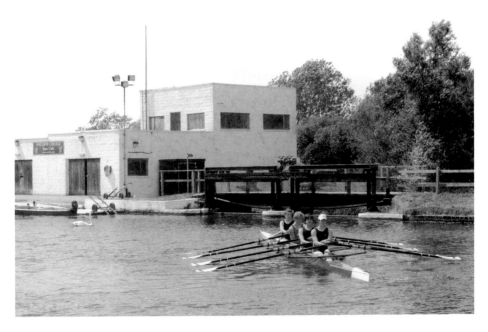

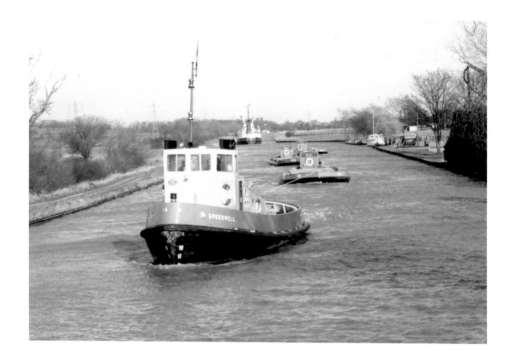

Tug *Speedwell* approaching Parkend Bridge towing three loaded mud hoppers in the 1980s. Mud that had been raised by the dredger was taken to a suction plant at Purton where it was pumped over the bank into the Severn estuary. The quay on the right was built in the 1920s for a Birmingham businessman's steam yacht, and it now provides moorings for pleasure craft.

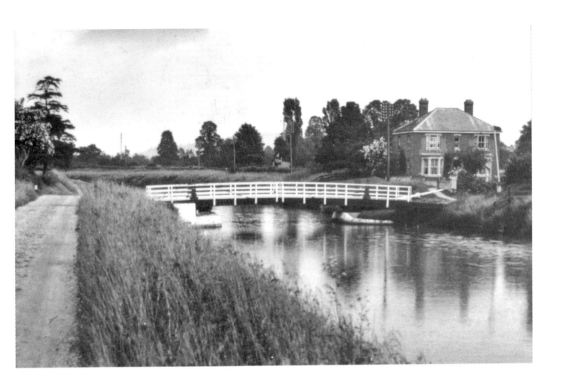

Hardwicke Bridge and Fairview House. The house was built for the coal merchant who had a wharf beside the bridge. As the bridge primarily served only Laynes Farm, following the provision of an alternative access, the crossing was closed in 1985 to save the cost of a bridge man and the bridge was subsequently removed.

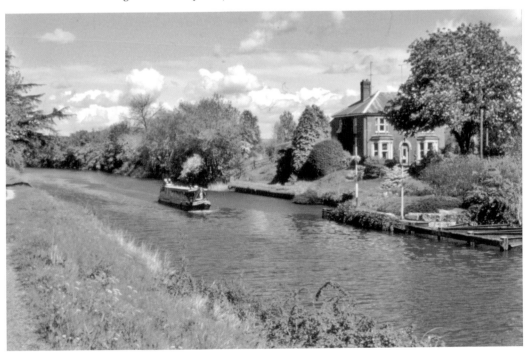

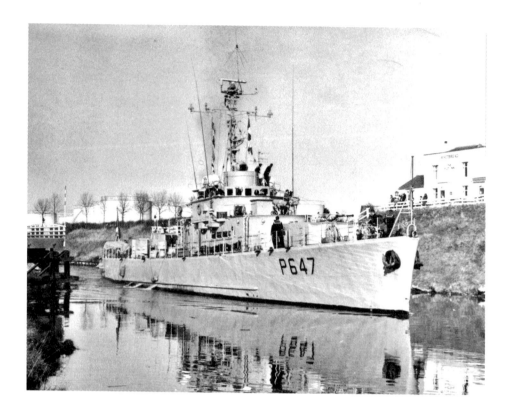

French corvette P647 passing Sellars Bridge and the Pilot Inn, March 1976, following a short courtesy visit to Gloucester. In the background can be seen the storage tanks of the Quedgeley Oil Depot. The same view in 2007 shows the passenger cruise boat *King Arthur* with the houses in the background built on the site of the oil depot.

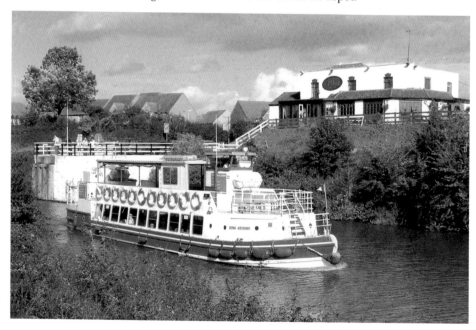

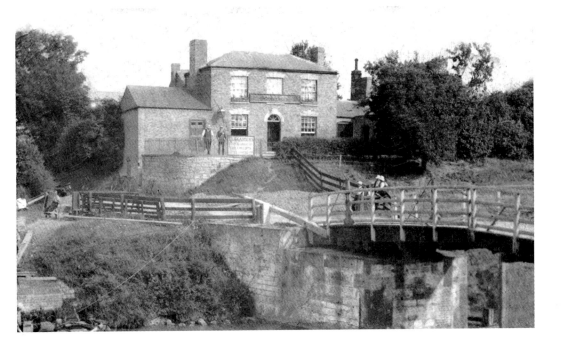

The Pilot Inn beside Sellars Bridge *c.* 1910. The pub was a popular port of call for serious rowers from Gloucester Rowing Club and of leisure rowers and their ladies in need of refreshment. The lower view shows that the pub has been extended and that the bridge has been realigned to alleviate the double bend in the road, leaving a small car park below the pub.

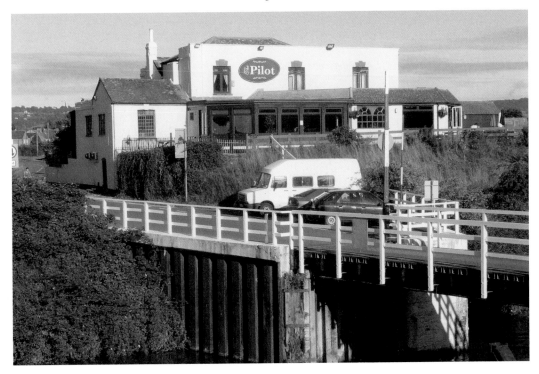

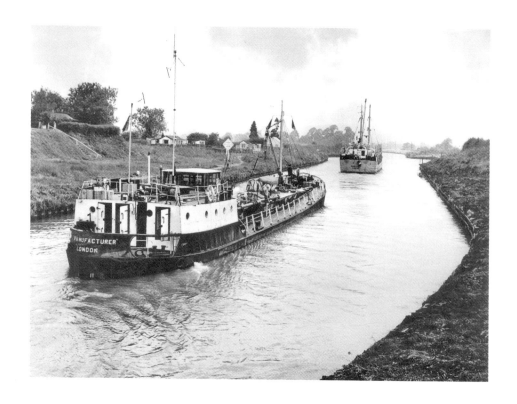

Tanker *BP Manufacturer* following a coaster north of Sellars Bridge. In the background can be seen some of the many holiday bungalows that lined the canal from here to Hempsted. The same view in June 2004 shows tug *Severn Progress* and barge *Sabrina 5*, from the Gloucester Waterways Museum, on their way to the Saul Waterways Festival.

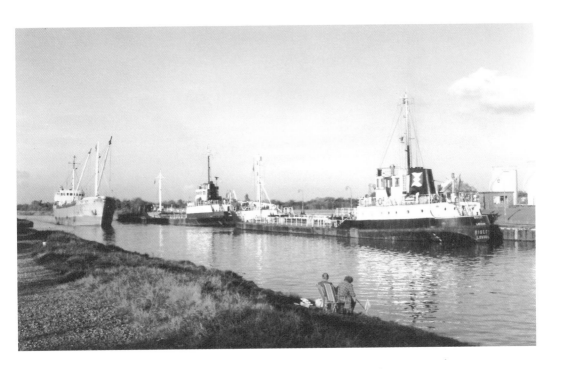

Two Bowker & King coastal tankers at the Quedgeley Oil Depot *c.* 1980. Five of these purpose-built vessels were introduced in around 1970 to carry petroleum products from Llandarcy to the depot, largely replacing the smaller barges that had previously handled this traffic. The oil depot closed in 1985 and has been replaced by a housing estate.

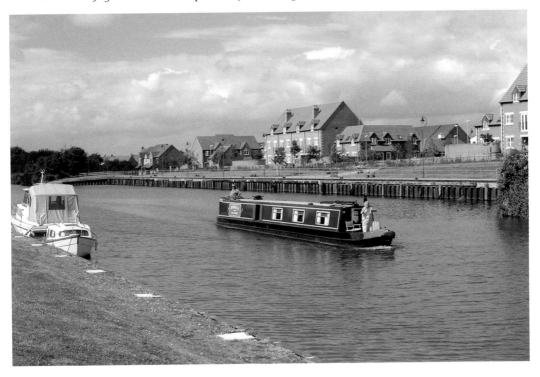

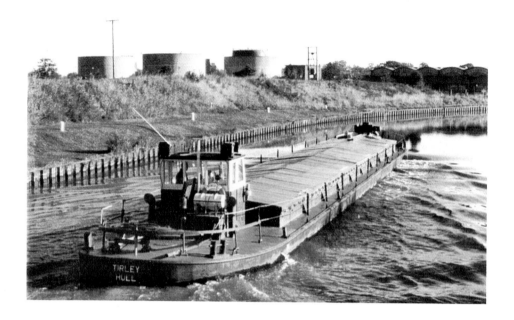

The motor barge *Tirley*, loaded with wheat for Healing's Mill at Tewkesbury, approaching Netheridge Turn just north of Sims Bridge *c.* 1980. This traffic was the last regular commercial use of the canal, this ending in 1998. The lower view shows how trees now hide the tanks of Gloucester Sewage Works, but the main buildings remain visible.

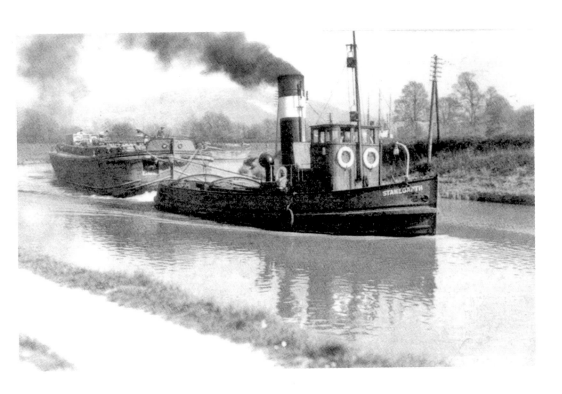

Steam tug *Stanegarth* towing empty lighters around Netheridge Turn approaching Sims Bridge. The first lighter is on short crossed ropes close behind the tug to help it steer round the bends. The lower picture shows that Netheridge Turn has been eliminated by the new cut crossed by Netheridge bridge (extreme left) leaving the original channel to the right as a side arm.

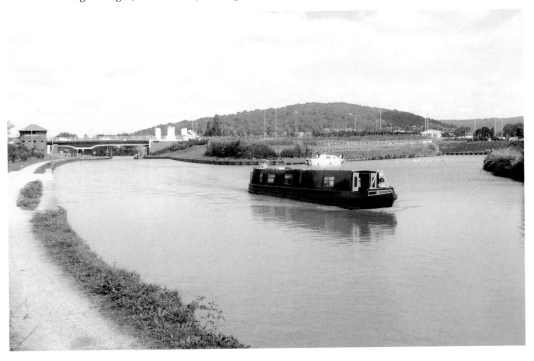

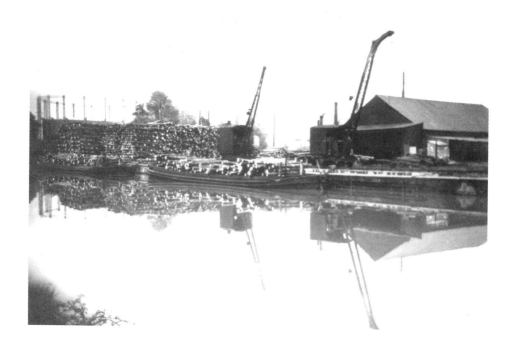

Riga Wharf piled high with aspen logs for S. J. Moreland & Sons in the 1950s. The logs were cut to a standard length and then taken by lorry to the firm's factory in Bristol Road for making into matches. The wharf was later used by a firm manufacturing oil-rig equipment, which was shipped out by coaster, and the lower picture shows the last heavy lift being loaded in June 2004.

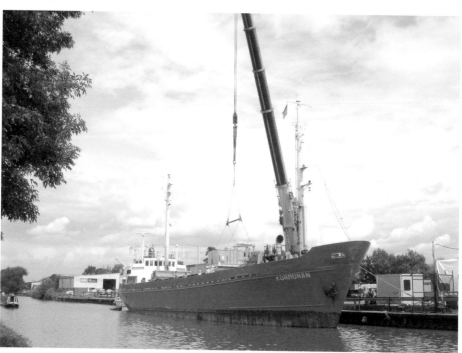

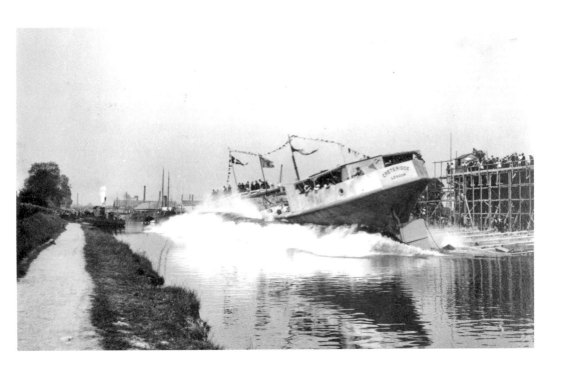

The launch of the huge concrete barge *Creteridge*, one of six built to the south of Hempsted Bridge as part of a national programme to replace shipping lost during the First World War. The lower picture shows that the site has not been reused commercially, as remains of the massive concrete slipways are still *in situ* under water.

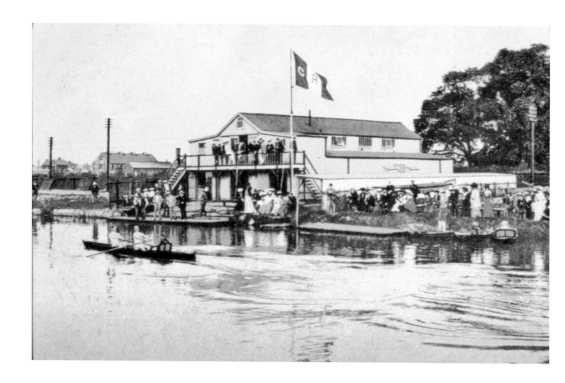

Gloucester Rowing Club to the south of Hempsted Bridge on a race day *c.* 1905. The pair passing the clubhouse were finishing well ahead of their rivals. The old boathouse has been replaced, but the lower picture shows there is still much excitement on race days.

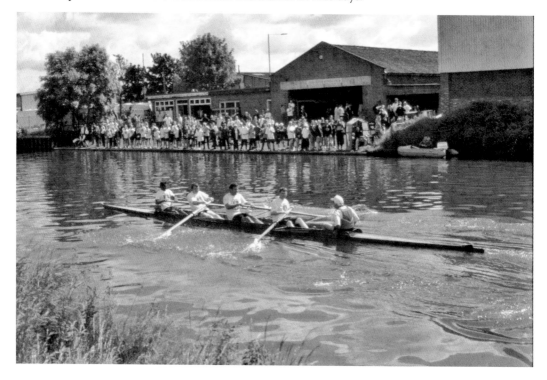

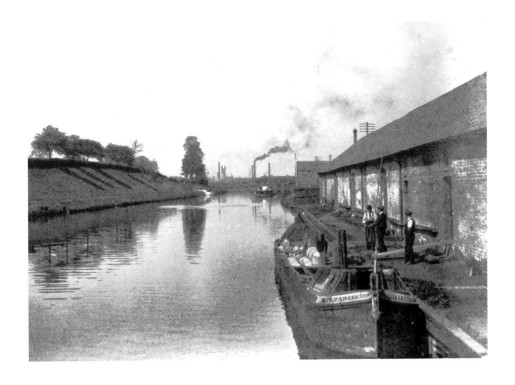

Drums of calcium carbide being loaded on to a longboat to the north of Hempsted Bridge
c. 1917. The long shed was originally built for storing Worcestershire salt for export, and
traces of salt can be seen in the brickwork. The shed is now used to store the Gloucester
Waterways Museum's reserve collection.

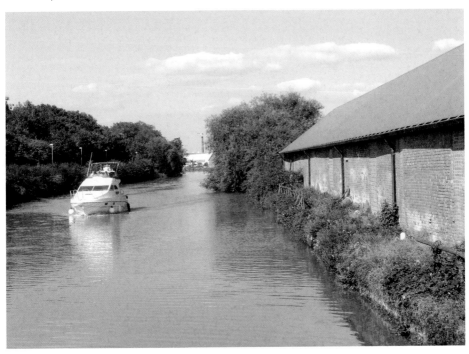

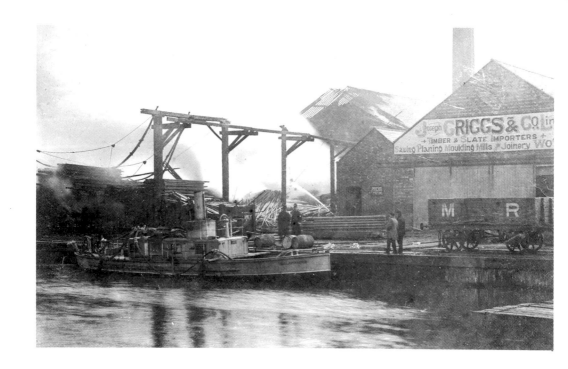

The fire-float *Salamander* attending the fire at Joseph Griggs & Co.'s sawmill in 1907. The fire had been started deliberately by a young man who said he wanted to see the fire-float at work. The lower picture shows that Griggs & Co. still have a sawmill on the site over a century later, but they no longer use the canal to receive or dispatch timber.

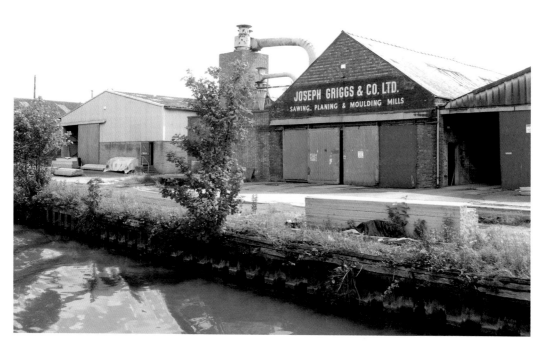

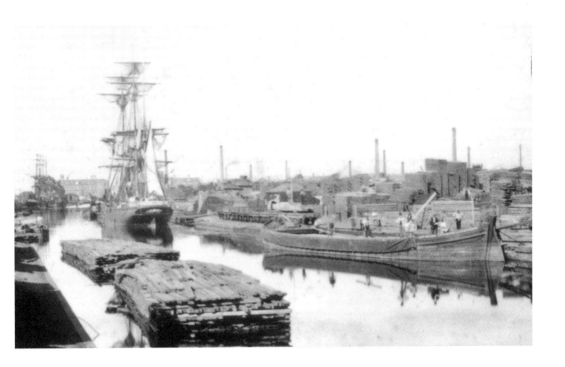

Timber yards on the east side of the canal in 1892 with a fine array of chimneys. The barque had brought 590 tons of boards direct from Norway, and men are unloading lighters containing timber discharged from larger ships at Sharpness. Now there is little to show of these past activities, although passengers on *Queen Boadicea II* may hear about them on a regular trip from the Waterways Museum to Netheridge Bridge and back.

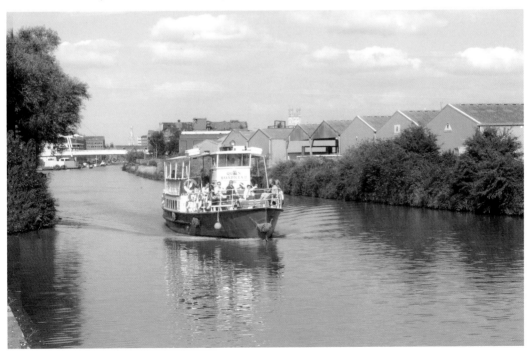

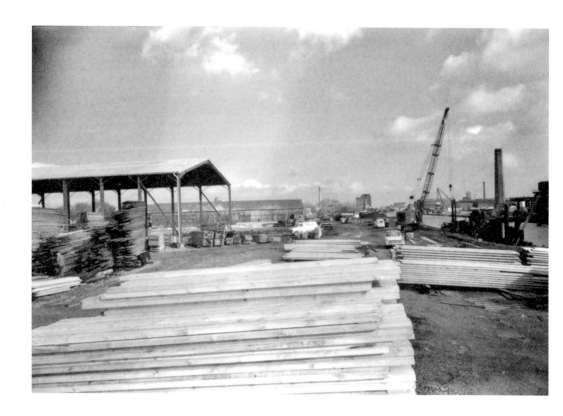

Monk Meadow Quay nearing completion in 1965 with the piling rig still at work. The new quay was mainly used for receiving and storing timber at a time when some of the older yards across the canal were being converted to other uses. Now the area has become a housing estate.

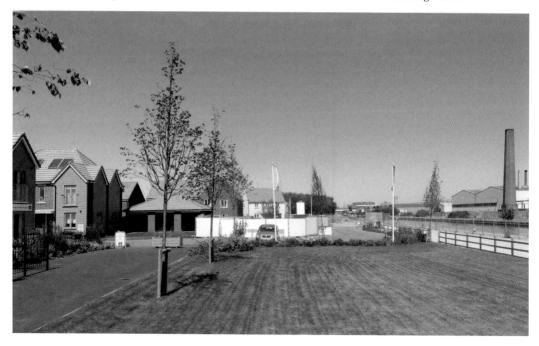

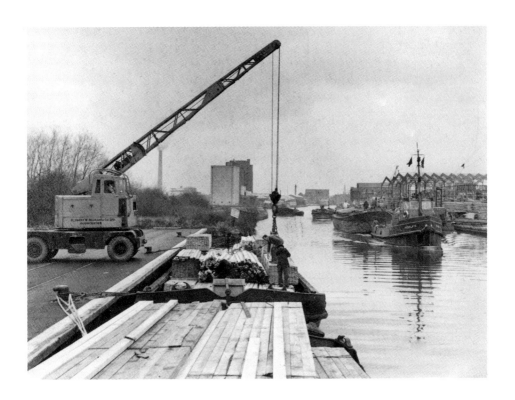

The first cargo of timber being discharged at the new Monk Meadow Quay using a mobile crane rather than having a gang of men carrying individual pieces on their shoulders. The same view in December 2009 shows the launch of the Bristol Channel Pilot Cutter *Cornubia* after refurbishment by T. Nielsen & Co.

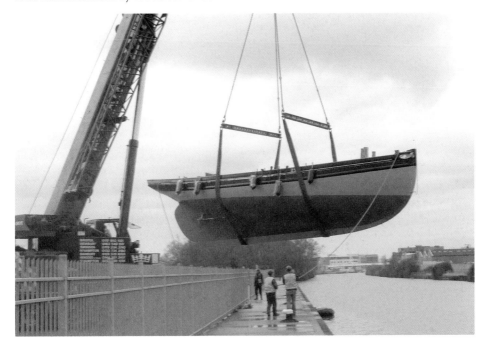

Coastal tankers in Monk Meadow Dock *c.* 1925. The depot behind was established by the Anglo-American Oil Company (later Esso), and the shed had formerly been a hangar at Rendcomb airfield. Now the dock is a marina for local pleasure craft.

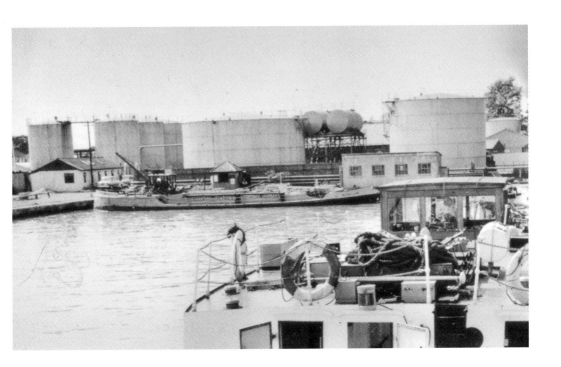

The western end of Monk Meadow Dock in around 1955 when five major oil companies had depots around the dock that were supplied by barges from Avonmouth. The same view in 2010 shows that four storage tanks remain, but these are now supplied by road tankers.

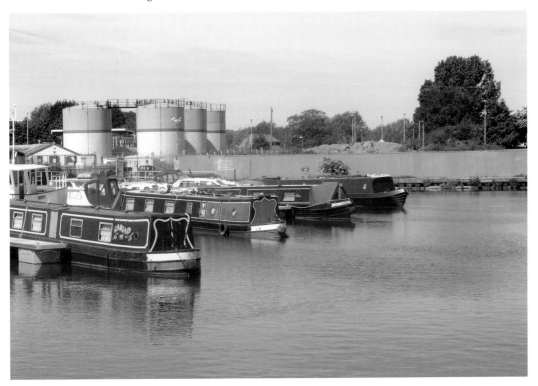

This site to the north of Monk Meadow Dock was only developed after the Second World War, and it had various commercial uses that were not related to the canal. The site is now occupied by a Sainsbury's food store with a café and balcony overlooking the canal.

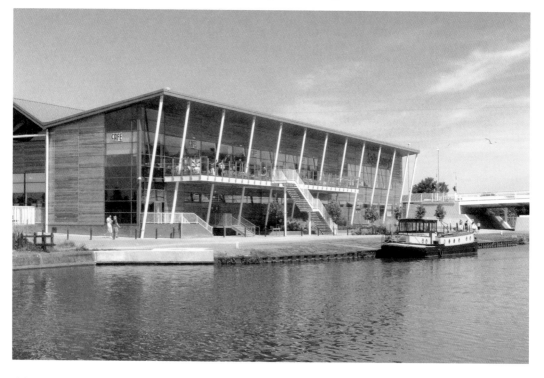

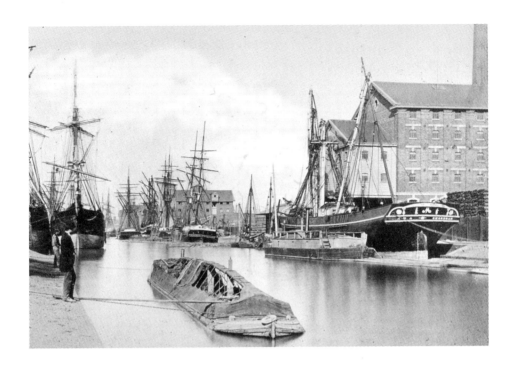

Bakers Quay, Gloucester, in 1867 with Foster Brothers oil & cake mill on the right and the Pillar Warehouse in the distance. The brig on the right has sheer-legs set up to lift the second mast back into position. The same view in 2010 shows how the new High Orchard Bridge has made a dramatic difference to the scene.

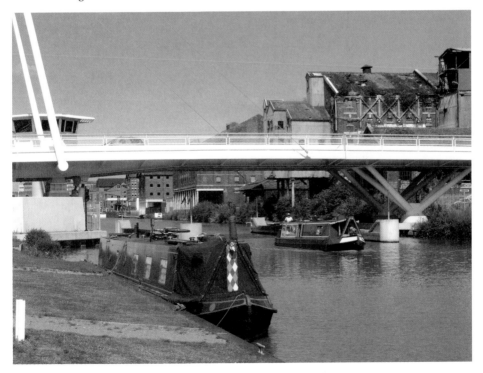

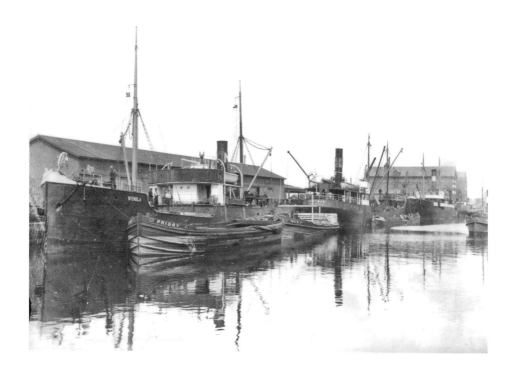

Steamers discharging at Llanthony Quay, Gloucester, in 1924. The shed on the left was used for the temporary storage of imports being sent on by rail. The same view in 2011 shows the lightship SULA (now a centre for complementary therapies) with the buildings of Gloucestershire College beyond.

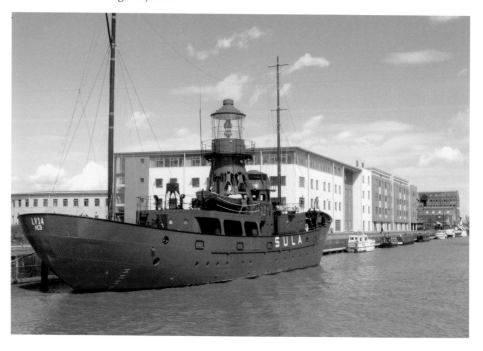

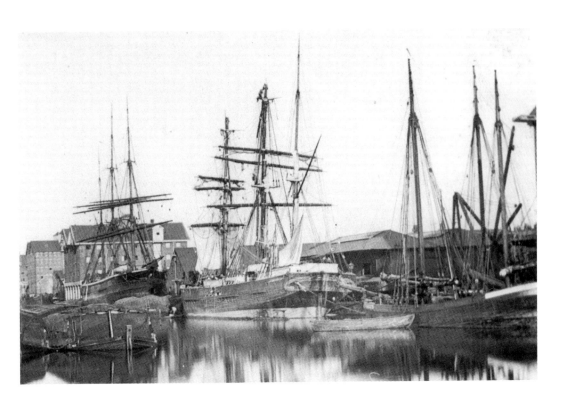

Sailing vessels moored by Bakers Quay in the 1880s with the Pillar Warehouse on the left and the Midland Railway transit shed mid-right (GA SRprints/GL22/105). The lower picture shows how the gap between the warehouse and the shed was later filled by the huge bulk of Downing's malthouses (now awaiting redevelopment).

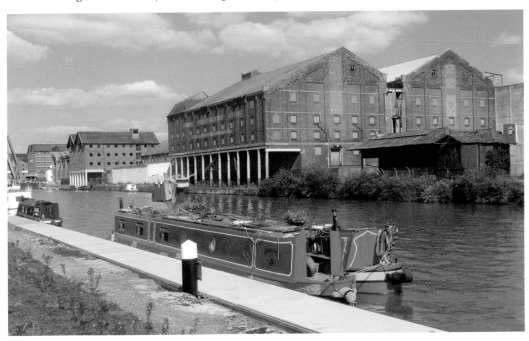

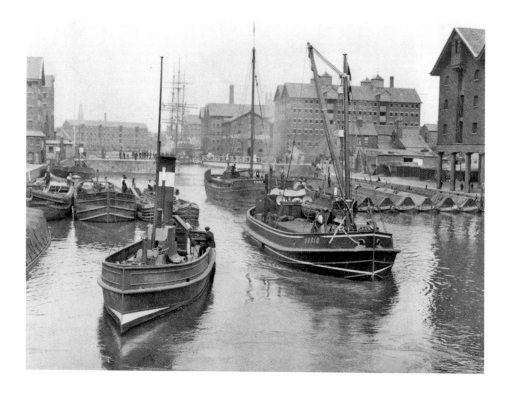

A busy scene south of Llanthony Bridge *c.* 1913. The Severn & Canal Carrying Co.'s motor barge *Osric* is setting off for Sharpness with dumb barge *Togo* while Dock Co. tug *Moss Rose* is preparing to tow some of the waiting lighters and narrow boats. The lower picture shows the complete change to leisure traffic, but all of the old buildings are still *in situ.*

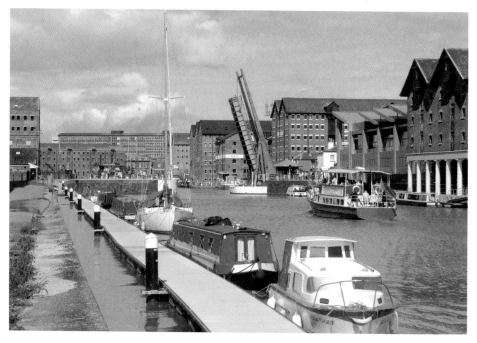

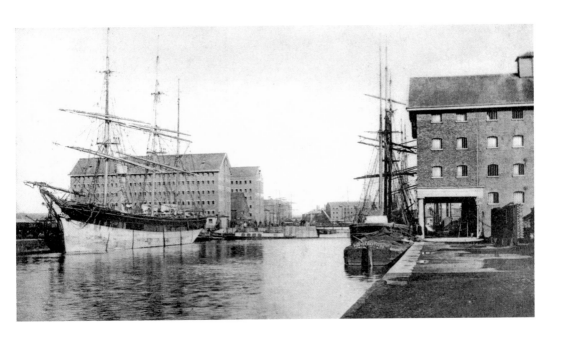

The view north from Bakers Quay in around 1895 with two barques near to Llanthony Bridge and the warehouses around the Main Basin in the distance. The large warehouse on the left is missing from today's view as it was badly damaged by a fire in 1945 and was subsequently reduced to a single-storey building.

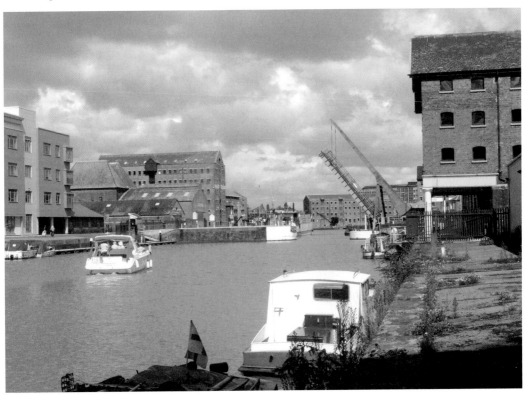

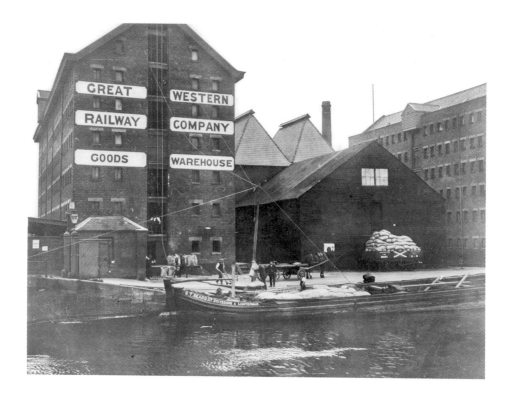

The Great Western Warehouse and Fox's black shed with Fox's malthouse behind. A guyed pole is set up on the quay to lift sacks from a lighter on to a horse-drawn cart. The lower picture shows that only the ground floor of the warehouse survived following a fire in 1945, and the black shed has been replaced by a brick shed.

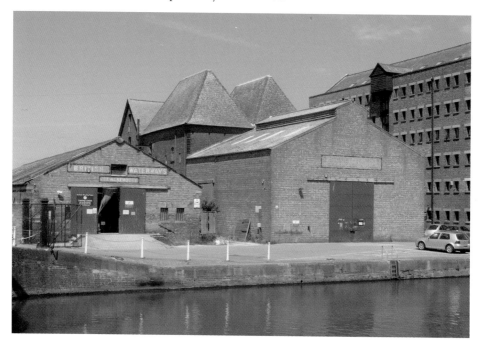

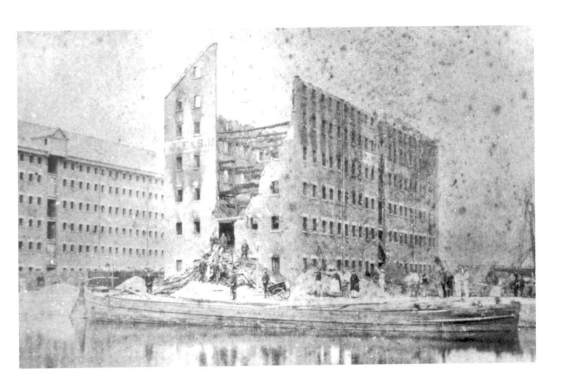

The Alexandra Warehouse after a disastrous fire in August 1875 which started in the eaves. As available pumps could not throw water up above the second floor, the fire had to be left to burn until it got down to this level. The lower picture shows that the warehouse was rebuilt with parapets in place of the eaves.

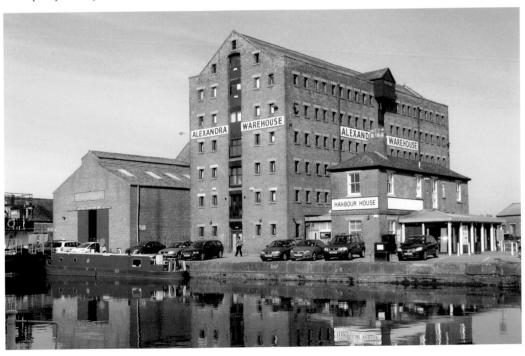

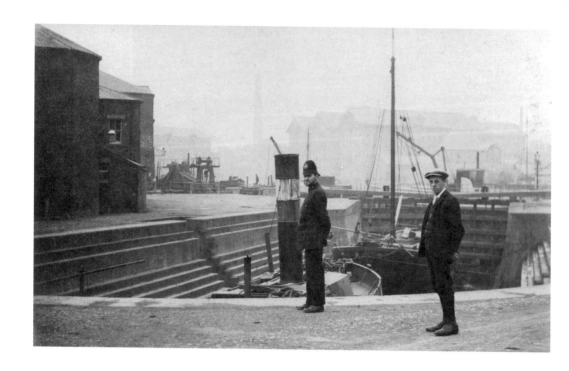

The large dry dock with one of the dock policemen on patrol. The dock was built for the largest ships that could come up the canal fully laden. The same view in September 2003 shows the gaff-rigged ketch *Queen Galadriel* under restoration by expert craftsmen managed by T. Nielsen & Co.

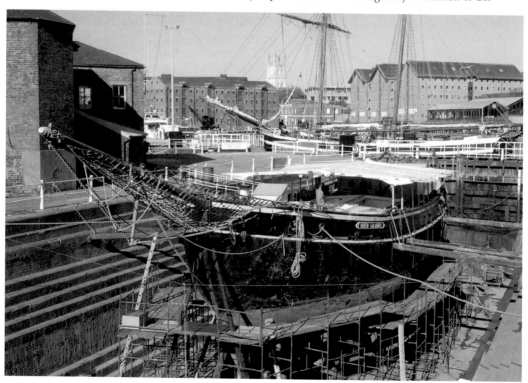

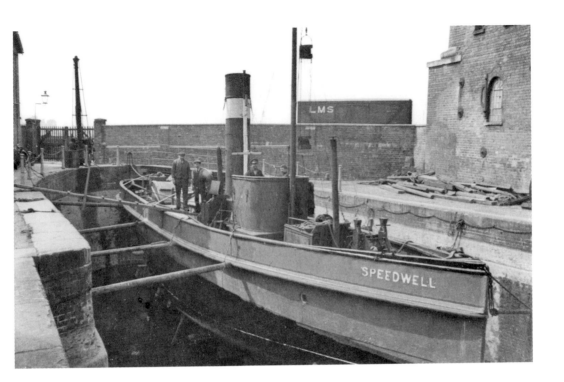

The small dry dock in 1936 with the Dock Company's steam tug *Speedwell* which had been towing vessels up and down the canal since 1876. The same view in May 2004 shows the Bristol Channel Pilot Cutter *Olga* undergoing an annual overhaul.

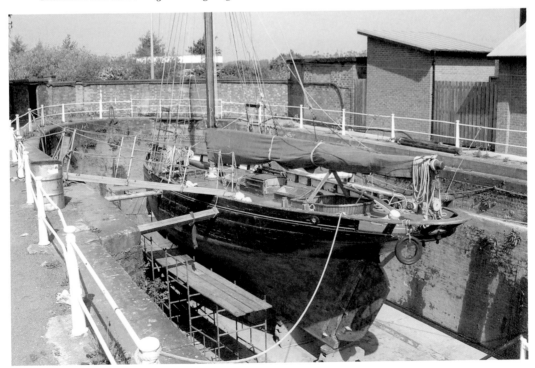

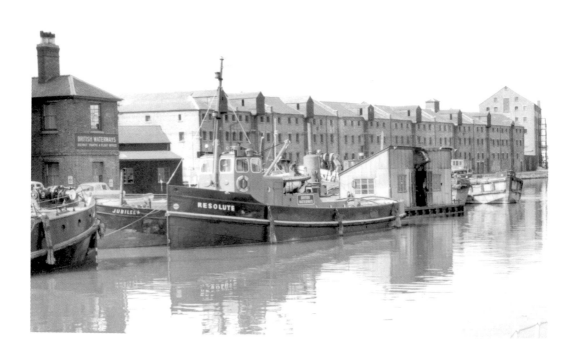

Vessels near the dry docks with the West Quay warehouses in the background *c.* 1960. Astern of the tug *Resolute* (recently converted from steam to diesel) is the mud suction plant from Purton and further right is a concrete barge. The same view in July 2012 shows much change with the hotel boat *Edward Elgar* in the foreground and the new West Quay apartments behind.

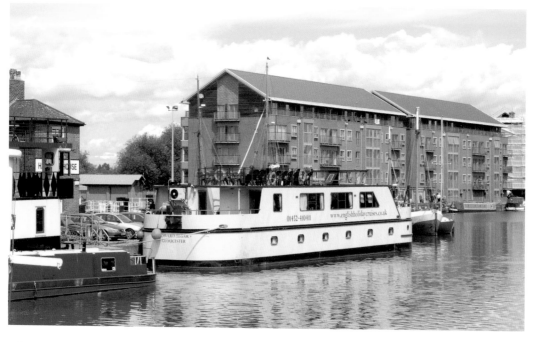

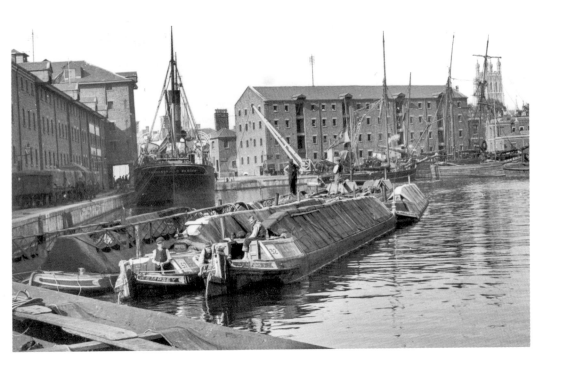

Loaded longboats owned by the Severn & Canal Carrying Company ready to set off for the Midlands via Gloucester Lock and the River Severn. The company had a large fleet of such boats that carried goods brought to Gloucester by barge from Bristol Channel ports. The same view in 2010 shows pleasure craft manoeuvring while waiting to lock down to the Severn.

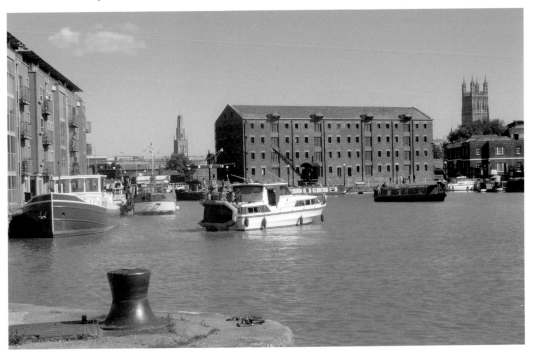

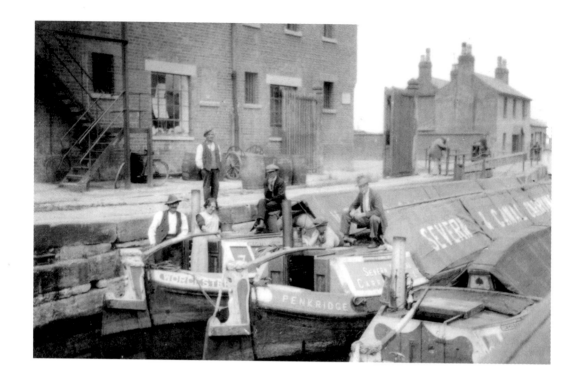

Severn & Canal Carrying Company longboats in Gloucester Lock in the 1930s. Each skipper had to find his own crew and often took members of his family with him, but most had homes in Gloucester to return to. The same view in 2010 shows that modern pleasure boaters have much more commodious accommodation than the working boat families.

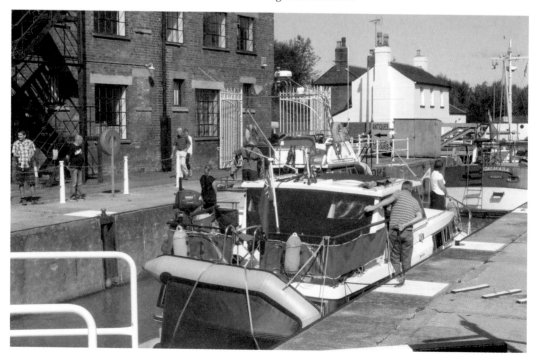

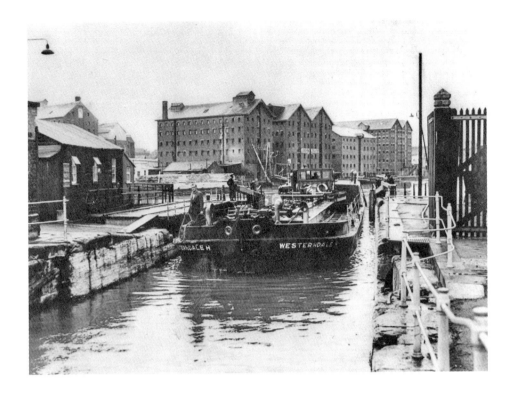

John Harker's tanker *Westerndale H* entering Gloucester Lock from the Main Basin in the 1950s. The black shed on the left was Mrs Boone's café where tanker men remember buying delicious sausage rolls for breakfast as they passed by. The lower picture shows the improvements to the lock made in the early 1960s when hydraulic equipment was installed to work the gates and paddle gear.

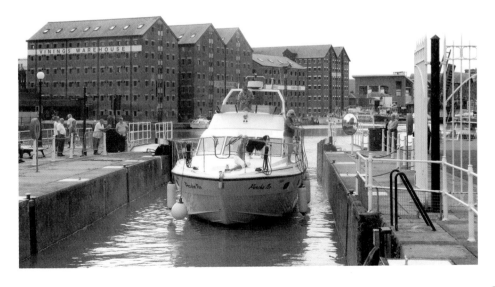

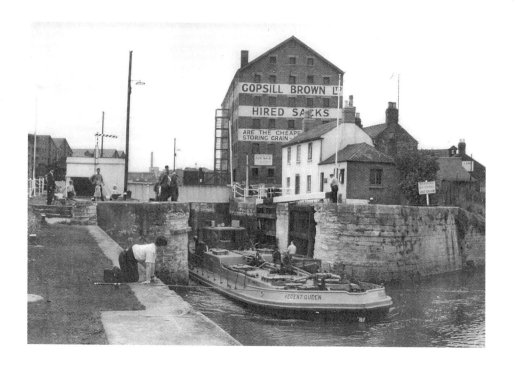

Tanker barge *Regent Queen* leaving Gloucester Lock *c.* 1960. Such was the quantity of petroleum products passing through Gloucester to the Midlands that tankers had to wait their turn in the Main Basin before locking down into the river. The lower picture shows that the lock can now be busy with pleasure traffic at times.

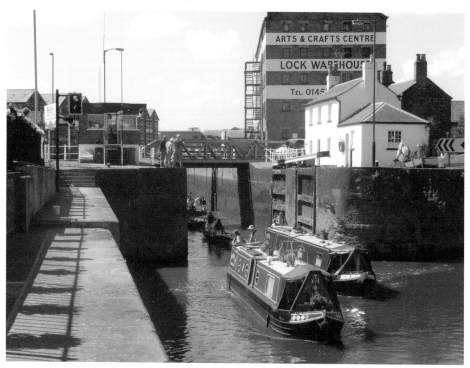

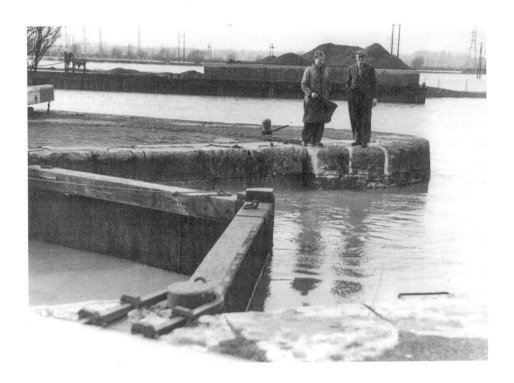

The stop gates at the river entrance to Gloucester Lock closed in March 1947 to protect the dock from the exceptional river flood (GA SR46/24291.28GS *Citizen* newspaper). The river level eventually peaked just below the top of the stonework. The same view on 24 July 2007, when the dock level had been deliberately lowered in case water flooded over the gates, but fortunately this did not happen and the river peaked at the same level as in 1947.

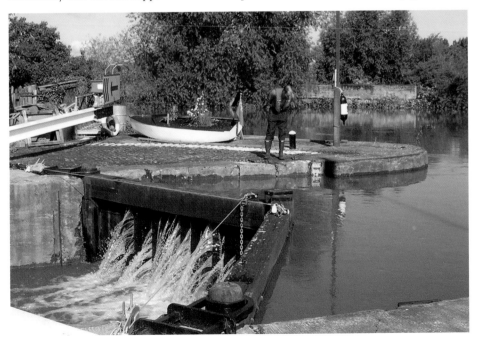

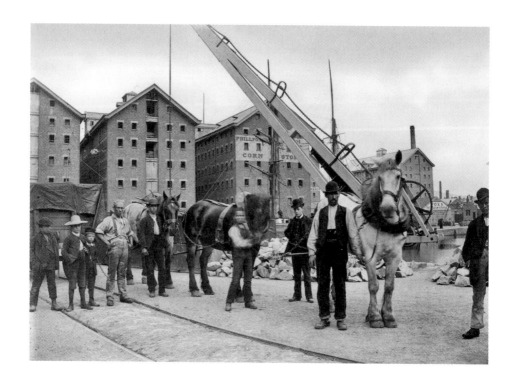

Midland Railway horses and a wagon on the North Quay *c.* 1887 (GA GPS154/488). The crane had evidently been used to discharge the road stone which is piled on the quay. The same view today includes a steam crane similar to those that were used around the docks in the early twentieth century.

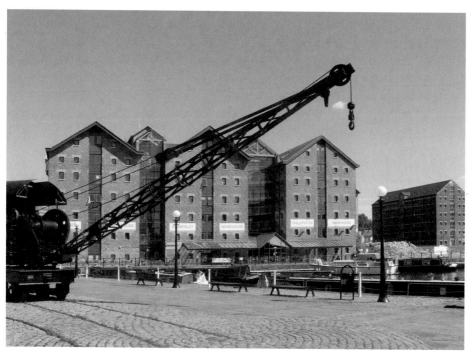

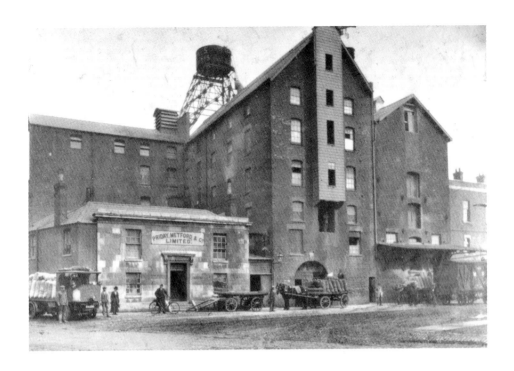

The City Flour Mills in around 1923 when it was managed by Priday Metford & Co., one of three mills around the docks processing imported wheat. The tank on the roof supplied sprinklers, which activated if a fire was detected. The lower picture shows the building now converted to apartments known as Priday's Mill.

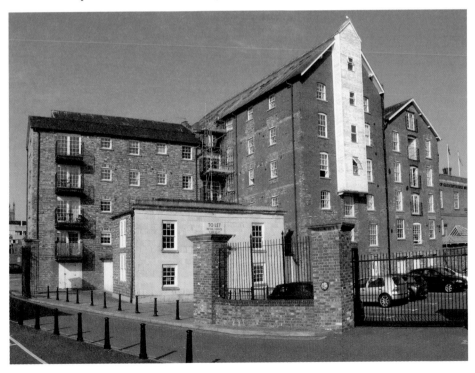

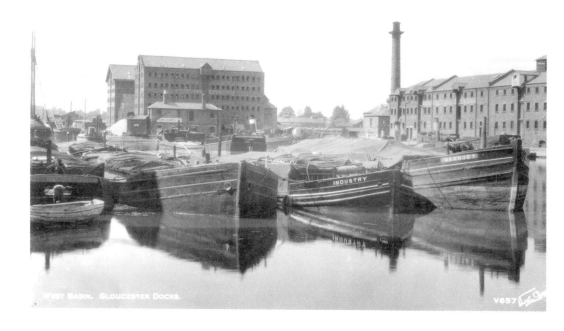

Barges moored in the Main Basin while waiting to be towed up the River Severn to the Midlands *c.* 1935. These wooden barges had once been sailing vessels. The same view today shows visiting pleasure craft, the movements of which add interest to the local scene.

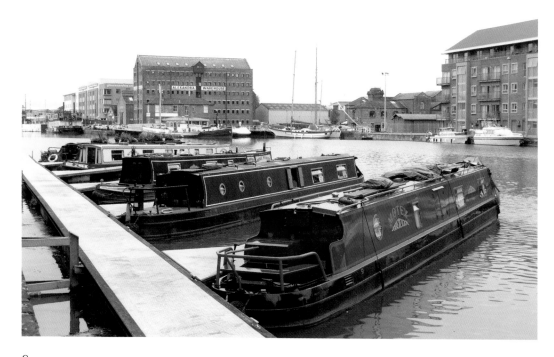

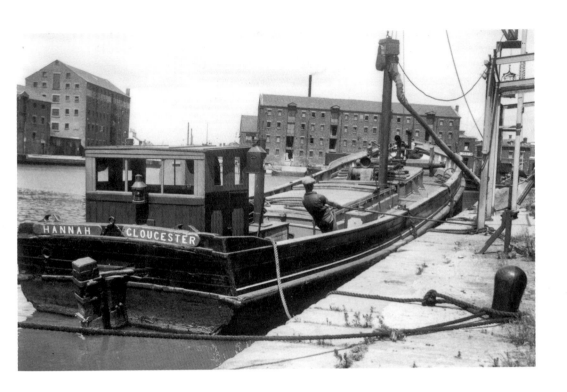

A Redler's elevator being used to transfer grain from the barge *Hannah* into Vinings Warehouse in 1934. The crewman is moving the barge along the quay so that the elevator can access another part of the hold. The same view in May 2008 shows boats gathered for the annual Three Clubs Regatta.

The barque *Gers* moored in front of Vinings, Reynolds and Biddle warehouses in September 1900 (GA B126/27985GS). Her cargo of Australian wheat is being discharged with the help of a floating steam winch alongside. The same view in May 2009 shows the modern barque *Kaskelot* at the bi-annual Gloucester Tall Ships Festival.

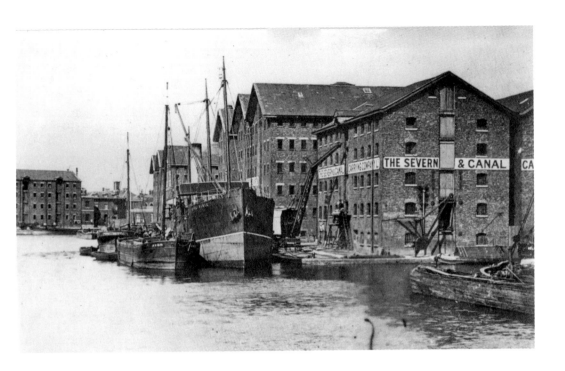

The steam coaster *Stock Force* simultaneously discharging to Biddle Warehouse and to the Severn & Canal Carrying Co.'s barges *Avon* and *Wye* alongside. Note the use of staging to support a platform level with the warehouse floor. The same view in October 2007 shows the modern barque *Earl of Pembroke* at the first Gloucester Tall Ships Festival.

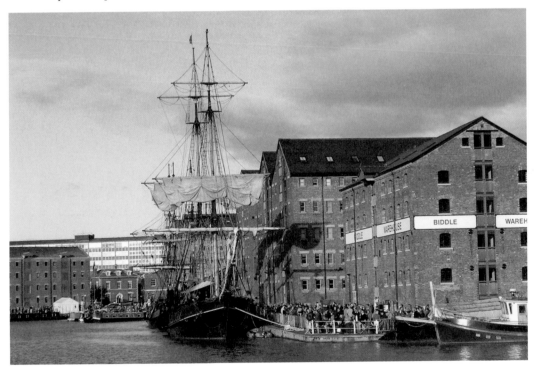

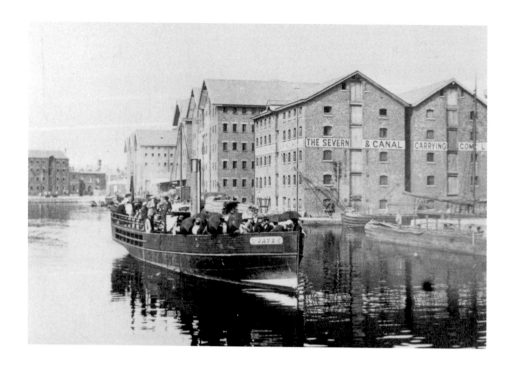

Passenger steamer *Wave* setting off for Sharpness *c.* 1910. *Wave* and sister steamer *Lapwing* carried Gloucester residents on business and pleasure trips to places down the canal and brought village people to the shops and market in Gloucester. Now *Queen Boadicea II* runs regular short trips from the Waterways Museum to Netheridge Bridge and back with an informative commentary provided by the skipper.

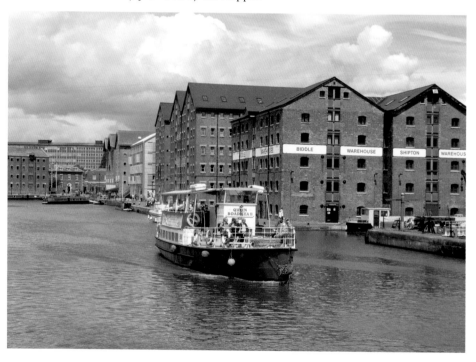

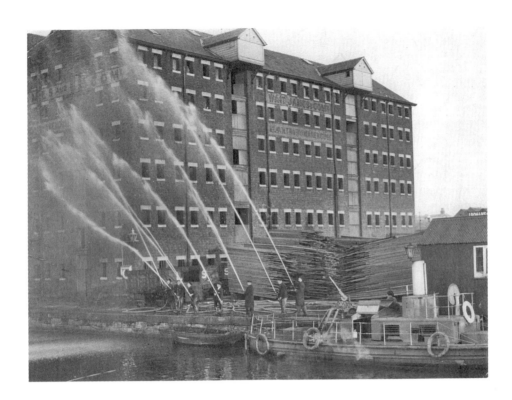

A test turnout for the crew of the fire-float *Salamander* in front of Llanthony Warehouse in the early 1930s. The men ran from the fire station, steam was raised and the pumps were working within ten minutes of the alarm being given. The warehouse is now home to the Gloucester Waterways Museum, which tells the story of life on Britain's rivers and canals.

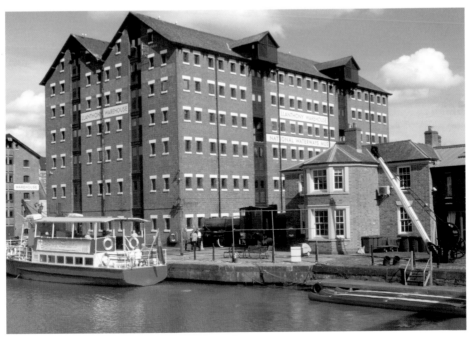

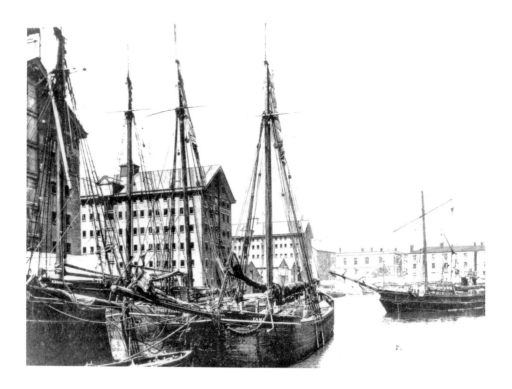

Sailing vessels in the Victoria Dock *c.* 1900. The dock and associated warehouses were built in the mid-nineteenth century to provide additional facilities for handling corn imports, and the dock was later used for the export of salt. Now the dock is a marina providing long-term moorings for pleasure craft.

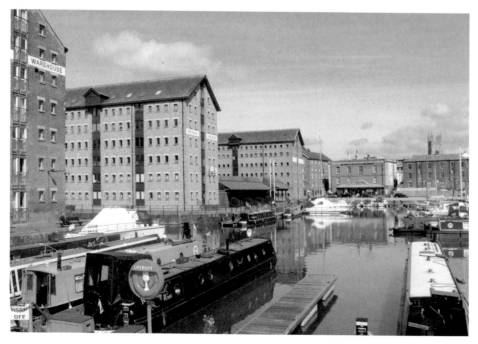

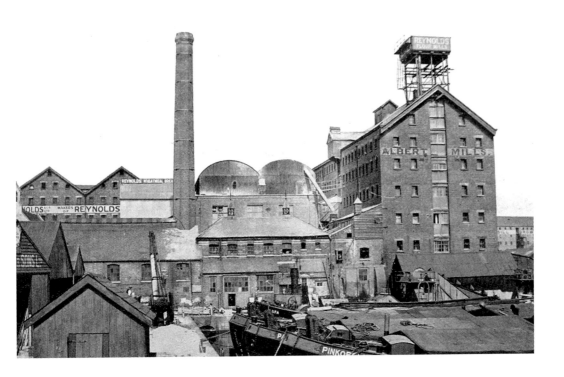

The Albert Warehouse was converted to a mill by James Reynolds & Co., and adjoining buildings were erected to house a steam engine, wheat-cleaning equipment and a sack store (GA NV15.3GS). Now the additional buildings have been demolished and the mill converted to apartments. Note the stump of the manually operated crane shown in the older picture.

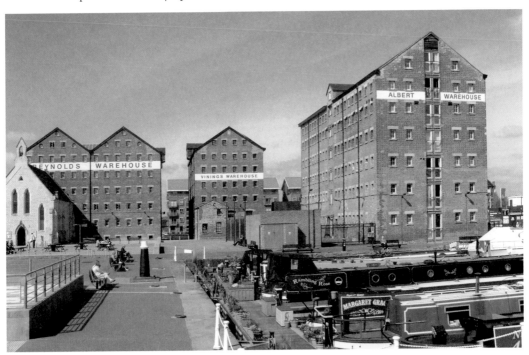

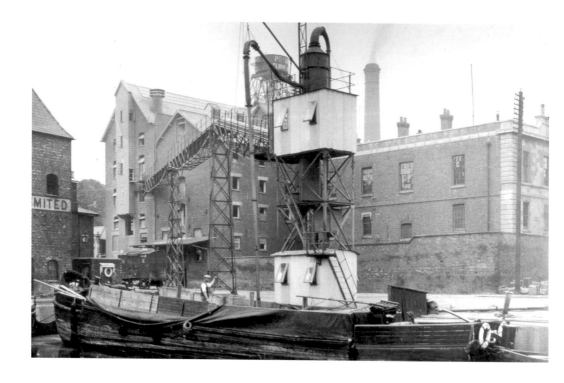

The wheat intake for the City Flour Mills at the north end of the Victoria Dock when new in 1925. The suction pipe and overhead conveyor replaced the earlier need for the wheat to be shovelled into sacks to be taken the few yards to the mill. Now there is a clear view of the former Custom House which is home to the Soldiers of Gloucestershire Museum.

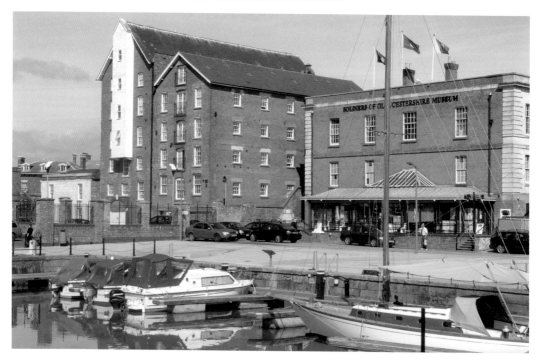

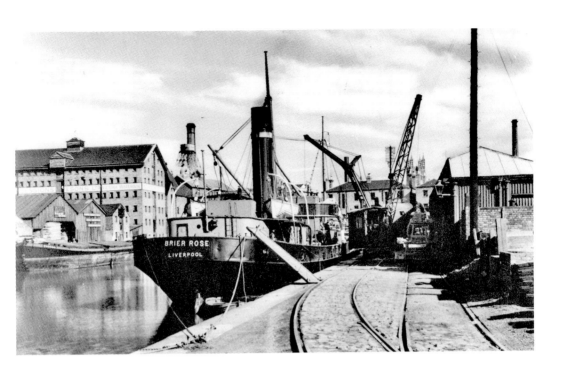

The steamer *Brier Rose* discharging cement into the transit shed on the East Quay of the Victoria Dock in the 1930s. The lower picture shows the walkway that has been created with high-quality paving and relaid railway lines along this side of the dock as part of a linkage between the Gloucester Quays outlet centre and the city centre.

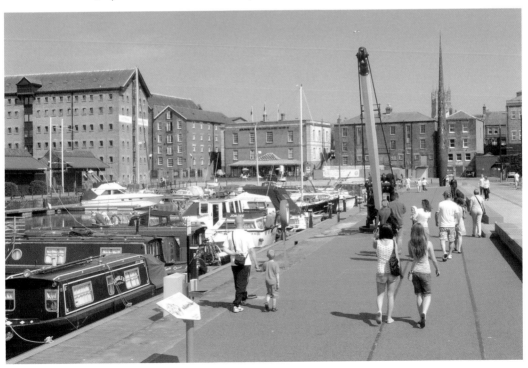

Deals being unloaded from a lighter in the Barge Arm in the 1930s. Two men lifted one or two deals on to the shoulder of a third man who ran across the planks and dropped the deals on to the appropriate pile in the timber yard. The Barge Arm is now home to the steam dredger and other historic craft looked after by the Gloucester Waterways Museum.

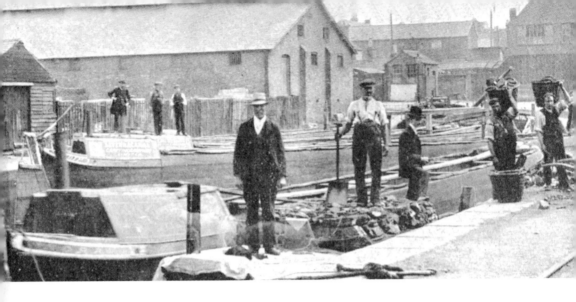

Coal being discharged from a longboat in the Barge Arm using baskets *c.* 1906 (GA IPB/46880GS 1915). Also in the picture are the chaplain and scripture reader from the Mariners' Chapel who spread the word of God to dock workers as well as to mariners. The lower picture shows the same location with four historic craft from the Gloucester Waterways Museum collection.

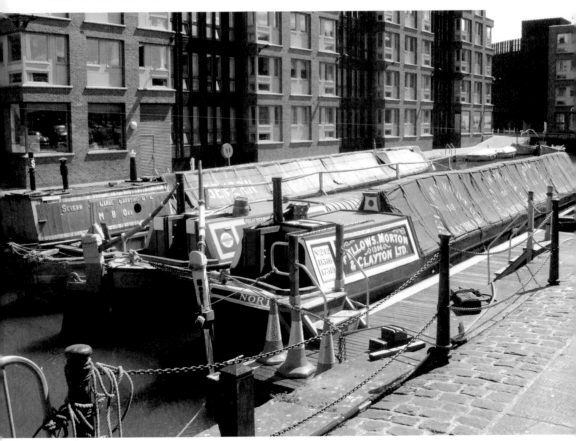

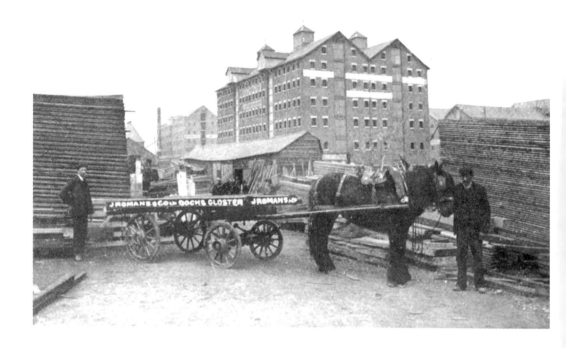

The timber yard of J. Romans & Co. to the south of the Barge Arm with Llanthony Warehouse in the background *c.* 1901 (GA N3.41GS). The site continued to be occupied by the firm into the 1980s, and then it became a car park in which the cast-iron columns supporting the shelters came from Romans' sawmill building.

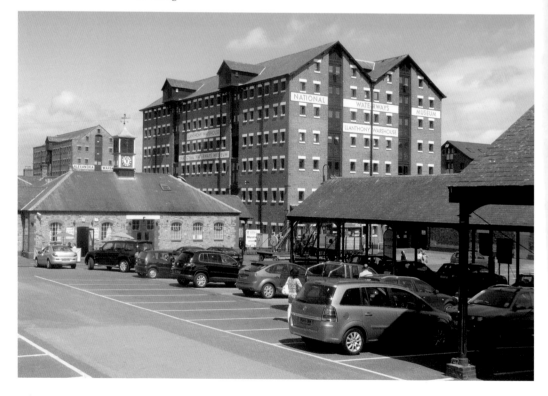